GOYA AND THE SATIRICAL PRINT

Artist,
in your timeless art,
Wit must weep,
and Horror laugh.

FROM RAFAEL ALBERTI,
"GOYA"

. . . I am not wrong
In calling this comic version of myself
The true one. For as change is horror,
Virtue is really stubbornness

FROM JOHN ASHBERY,
"THE PICTURE OF LITTLE J.A.
IN A PROSPECT OF FLOWERS"

Ya tienen asiento.

Goya and the Satirical Print in England and on the Continent, 1730 to 1850

Reva Wolf

David R. Godine, Publisher
Boston
ion with Boston College Museum of Art

Boston College Museum of Art
Chestnut Hill, MA 02167

Library of Congress Catalog Card Number: 90-85719
ISBN: 0-87923-925-5 softcover (Boston College Museum of Art)
ISBN: 0-87923-897-6 hardcover (David R. Godine, Publisher,
in association with Boston College Museum of Art)

Photo Credits:
Photographs courtesy of the collections indicated on
pp. 101-108
Cover illustration:
Francisco Goya, the *Caprichos*, plate 29, *Esto si que es leer*,
c. 1797-98 (no. 23)
Frontispiece:
Francisco Goya, the *Caprichos*, plate 26, *Ya tienen asiento*,
c. 1797-98 (no. 38)

Poetry Excerpts, p. i:
Rafael Alberti, "Goya," *A la pintura* (1953), trans. Nigel
Glendinning, *Goya and his Critics*, London and New Haven, 1977, p. 251
John Ashbery, "The Picture of Little J.A. in a Prospect of
Flowers," *Some Trees* (1956), New York, 1978, p. 29

Design: Boston College Office of Communications,
Jana Spacek with Pat Dunbar
Typesetting: WordTech Corporation
Printing: Macdonald & Evans

Contents

PREFACE

Although the graphic work of Goya has been explored by many scholars and in several recent exhibitions, the sources of his work in the printed satirical images of his predecessors and contemporaries have been largely ignored. The Museum of Art at Boston College is therefore pleased to present the first exhibition and accompanying book to illustrate the extensive recycling of stock images in satirical prints, and to show how this imagery was passed down from one generation to the next of artists of lesser talent, and transformed by Goya into statements of extraordinary visual power. It also emphasizes in a new way the importance of commerce for the dissemination of satirical prints, especially from England to the Continent.

Reva Wolf, Assistant Professor of Fine Arts at Boston College, a scholar of Goya's work, conceived of the show, organized it, and wrote this essay. To her the Museum owes its greatest debt of gratitude. We are indebted as well to Alston Conley, who, as acting director, oversaw the project at its inception, assisted in the preliminary stages of securing loans, and submitted grants for funding. Of course, none of this could have been done without the invaluable assistance of the Museum's indefatigable Administrative Assistant, Helen S. Swartz. The enthusiastic support and assistance of J. Robert Barth, S.J. (Dean of the College of Arts and Sciences), Charles F. Flaherty (Director of University Research) and his staff, Jeffery W. Howe (Chair of the Department of Fine Arts), Julio José López Jacoiste (Consul General of Spain in Boston), William B. Neenan, S.J. (Academic Vice-President), Jana Spacek (Director of Design Services), and the Friends of Art at Boston College are also gratefully acknowledged.

A portion of this exhibition, which under the terms of its bequest to Harvard University could not be lent, is exhibited simultaneously in the rotunda of the Widener Library at Harvard. For this display we are grateful to James Lewis, the collection's curator. We are also pleased that the exhibition is traveling to the Spanish Institute in New York, and thank especially Suzanne Stratton, curator of exhibitions, for her indispensable role in making this possible.

The complex elements of this show made it a costly endeavor. Were it not for the generous support of the National Endowment for the Arts, neither the exhibition nor this book would have been possible. We have also been fortunate in the way in which lending institutions agreed to our requests to borrow fine works of art. It is due to them above all that the new ideas explored in this exhibition emerge so clearly and that the contents are as visually compelling as they are.

A final word of gratitude is due the administration of Boston College, whose continuing support of the Museum of Art, and whose understanding of the Museum's mission to serve both the university community and the public is essential to the achievement of every project.

Nancy D. Netzer
Director
Boston College Museum of Art

Acknowledgments

Several individuals and organizations contributed to making this exhibition and book possible, and I would like to express my gratitude to them. A Faculty Research Incentive Grant from Boston College allowed me to begin work on the project. I benefitted invaluably from my study of the print holdings at the Yale Center for British Art, the Beinecke Rare Book Library, and The Lewis Walpole Library during my tenure at the Yale Center for British Art as a Visiting Fellow. A Special Exhibitions Grant from the National Endowment for the Arts helped to fund the exhibition and this publication, the content of which I hope the Endowment will reflect on with regard to its relevance for contemporary art.

I thank the individuals at the lending institutions who so generously agreed to loan the works, and who assisted me in countless other ways in the process of putting this exhibition together: Vincent Giroud, Curator of the General Collection, and Christa Sammons, Curator of the Yale Collection of German Literature, Beinecke Rare Book Library, Yale University; Sinclair Hitchings, Keeper of Prints, and Karen Smith Shafts, Assistant Keeper of Prints, Print Department, Boston Public Library; Marie Devine, Librarian, and Joan Sussler, Curator of Prints, The Lewis Walpole Library, Yale University; Bernard Reilly, Curator, Prints and Photographs Division, and Tambra Johnson, Exhibits Office, Library of Congress; Colta Ives, Curator in Charge, Department of Prints and Photographs, The Metropolitan Museum of Art; Clifford Ackley, Curator, Sue Welsh Reed, Associate Curator, and Stephanie Loeb Stepanek, Research Associate, Department of Prints, Drawings, and Photographs, Museum of Fine Arts, Boston; Cara Denison, Curator of Drawings, The Pierpont Morgan Library; David L. Acton, Curator, Department of Prints and Drawings, Worcester Art Museum;

Duncan Robinson, Director, Joan Friedman, Curator of Rare Books, and Patrick Noon, Curator of Prints, Yale Center for British Art. I would also like to thank the other staff members of the Center for British Art who helped me in numerous ways while I was a Resident Fellow there, including Constance Clement, Assistant Director for Education and Information, Anne-Marie Logan, Reference Librarian and Photo Archivist, Betty Muirden, Public Services Assistant, Library, and Laura Guadagnoli and Laura Malkus, Print Room Assistants. In addition, I am grateful to James Lewis, Curator of the Houghton Library and of the Widener Memorial Room at Harvard University, for having arranged for the presentation of a segment of this exhibition at the Rotunda of the Widener Library. A few individuals at the lending institutions—Karen Smith Shafts, Patrick Noon, and Joan Sussler—gave considerably of their time and knowledge, and without their on-going support this exhibition would not have occurred. I am deeply indebted to them.

The support of the Fine Arts Faculty and Administration of Boston College have also been essential to the realization of this project. I especially thank Jeffery W. Howe, Chair of the Fine Arts Department, J. Robert Barth, S. J., Dean of the College of Arts and Sciences, William B. Neenan, S. J., Academic Vice President, and Katharine Hastings, Assistant to the Academic Vice President, for standing behind me at every stage. I also thank Mary Carey, Adminstrative Secretary, Fine Arts Department, for always being there at times of need. The staff of the Museum of Art assisted in details large and small of making arrangements for the exhibition. As acting director, Alston Conley, with the advice of John Chandler, helped me prepare the grant proposal for the National Endowment for the Arts. Helen S. Swartz, Administrative Assistant, helped with

everything from grant proposals to photograph orders. Nancy D. Netzer went beyond the call of duty in helping with funding and loans before officially taking up her post as Director. A special thanks goes to my student Jason Drucker, who patiently and with great care assisted me in filling out loan request forms. Another student, Laura Channing, tracked down bibliography.

Several colleagues, friends and relatives offered support and advice while I wrote this essay. Thomas Frick, Editor at David R. Godine, Publisher, Inc., provided invaluable editorial assistance. Joanna E. Fink and Sherry Hahn were also excellent editors. In addition, they both most generously spent several hours discussing with me various problems that the essay posed. Also generous in this regard were Gerard Malanga and Susan Wides. My father, Abraham Wolf, and my sister, Beverly Hartzman, stood by me throughout.

The subject of this study is based on a section of my Ph.D. dissertation, *Francisco Goya and the Interest in British Art and Aesthetics in Late Eighteenth-Century Spain*. I reiterate here my gratitude to my dissertation advisors, Jonathan Brown and Robert Rosenblum, for many years of guidance. They also offered wise advice concerning this exhibition. I am especially grateful to Jonathan Brown for having proposed the exhibition to the Spanish Institute in New York.

This essay is built on several previous studies, many of which are cited at the appropriate places within the text, and which I would like to acknowledge here. The main studies to have suggested connections between Goya and England are López-Rey, 1945 and 1953, Klingender, 1948, Malraux, Antal, Salas, Hofmann, Busch, and Hasse (refer to the bibliography for a key to the abbreviations). The most important contributions to our understanding of the dissemination of satirical prints are George, all publications. For the development of specific themes in caricature, the most significant works are Klingender, 1944, Antal, and Hasse.

Reva Wolf

NOTE: Numbered plates are works in the exhibition. Additional plates are designated as "figures."

~∾ INTRODUCTION ∾~

A keen observer of society, Francisco Goya penetrated both artistic and social conventions in his art, and confronted directly the darkest but most basic human impulses. In his print series, the *Caprichos*, executed from around 1796 to 1798, he ridiculed the foibles of society with a power and subtlety in imagery, concept, and technique that have left a strong impact on viewers since the early nineteenth century. Contributing to the force of these works is the fact that Goya never placed himself above the society that he criticized; he recognized that he was as much a product of that society as the next person. He was even capable of making himself the subject of his own mockery. In a caricature that he drew of himself at the close of a letter to his friend Martín Zapater (fig. 1), the extreme protrusion of his chin is of course a gross exaggeration, while his paunch makes him amusingly similar to his own satirical depictions of gluttony. As if to ensure that Zapater would know that the subject of the caricature was Goya, the artist included a caption, which emerges from his mouth: "this is how I am" (*"así estoy"*).

The dateline of this letter reads "London August 2, 1800" (fig. 2). It is generally assumed that the dateline is a joke, since, so far as we know, Goya never went to London.[1] Although the specific meaning of the reference to London is unknown, Goya's intuitive association of caricature with the English capital strongly suggests that he viewed caricature as an English genre. The similarities of several of the eighty plates of the *Caprichos* to the imagery of English satirical prints indicate, further, that his knowledge of such prints was extensive. He had by this time incorporated the vocabulary of the English works, along with those of other print traditions (most notably, that of the Italian *capriccio*), into his own richly associative artistic language.[2]

Goya was interested in English satire of all types, ranging from William Hogarth's detailed, engraved narratives of the 1730s to social and political prints in which the figures are caricatured, a format that had made its appearance in the 1750s, and grew rapidly in quantity and popularity over the next several decades.[3] In the

1730s, Hogarth began to sell collections of his prints in bound volumes. This procedure was inherited by his successors in England as well as by Goya.

Several elements of the English prints are found in Goya's work. He borrowed stock settings and characters of the English caricatures, such as the barber shop or hairdresser's, or the over-indulgent cleric seated at a table. He also appropriated specific poses, such as that of a man with sprawled legs. The faces of his figures are often exaggerated, as in the English images. The *Caprichos* are accompanied by brief, often ironic captions that are inscribed under the image, like many of their English counterparts.

In concept, Goya's work is closely related to that of Hogarth. Both Hogarth and Goya were painters who viewed their prints as an extension of their other work and of equal artistic merit. Both compared their work to traditions of satire in literature. Both endeavored to produce satirical art that would transcend specifics of time and place.

In style, however, Goya's work is unrelated to that of Hogarth, but has more in common with the English caricatures of Goya's contemporaries. These images are often simple in composition, in contrast to Hogarth's crowded scenes, with only one or a few figures and undefined backgrounds. Several of the English works, like the *Caprichos*, were executed in etching combined with aquatint, a then recently discovered technique for producing tonal variations.[4] In some instances, the use of several layers of aquatint and the abstract patterns that it produced on the page in the English prints come close in their subtlety to Goya's images. Goya, however, tended to cover the entire sheet with the aquatint tone, while the English printmakers tended to apply it to selected passages, leaving the background white. The darker backgrounds of the *Caprichos* parallel the darker psychological tenor of Goya's work.

To be sure, Goya had his own agenda. While he borrowed various conceptual and stylistic elements from the English artists, his work, unlike theirs, is not funny. Hogarth claimed to be a moralist; Goya never referred to his work as moralizing. In the well-known advertisement for the *Caprichos* that was published in the newspaper *Diario de Madrid* on February 6, 1799, the prints are characterized as ridiculing vice and error, but the word "moral" is nowhere to be found.[5] Goya knew that he was as prone to folly as the

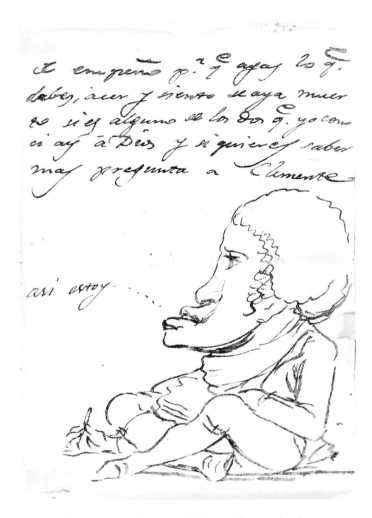

Fig. 1.　Francisco Goya, Caricature Self-Portrait Drawing in a Letter to Martín Zapater, dated "*Londres 2 de agosto de 1800*," brown ink

Fig. 2. Francisco Goya, Letter to Martín Zapater, page 1, dated "*Londres 2 de agosto de 1800*," brown ink

figures found in his prints, and that the simplistic formula of "right" and "wrong" is often inapplicable to the complex reality of a given situation. He ridiculed absurd behaviour, but he also recognized that it was basic to human nature.

The English prints undoubtedly fascinated Goya precisely because they are about human nature. However, it was only on account of the more general interest in these prints throughout Europe during the last quarter of the eighteenth century—matters of taste and commerce—that Goya was exposed to them to begin with. In this study, I will illustrate how such matters came to have a bearing on Goya's work, and in what ways. I will also offer explanations for the popularity of particular images, which endured well after Goya's lifetime. Finally, I will show how Goya's criticism penetrates the codes of the English images to expose the hypocrisy of their function, which was to make people laugh at the foibles of others.

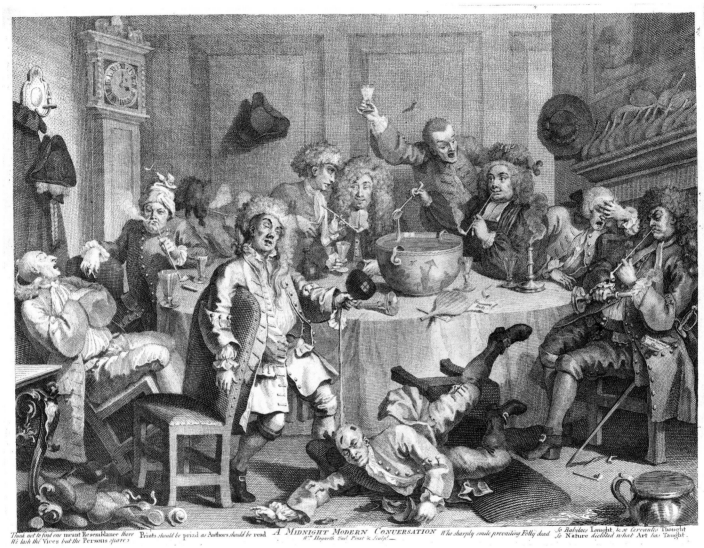

No. 1. William Hogarth, *A Midnight Modern Conversation*, 1732-33, etching and engraving

THE *CAPRICHOS* AND THE DISSEMINATION OF
∼ THE ENGLISH SATIRICAL PRINT ∼

It is unfortunately very much the prerogative of this Paper Age of the World that, since the Universe has become the subject of the book and picture trades, thousands of writers and artists have grown blind to the direct rays of Nature, but see quite satisfactorily if this ray is reflected from a sheet of paper. It is fortunate if the reflection is always at first hand, and if the page itself is always as clear, as neat, and as mirror-bright as that which our great artist holds up to us here.

LICHTENBERG ON HOGARTH, 1794[1]

Practically from the moment of their publication, viewers of the *Caprichos* instinctively associated them with English satirical imagery. In 1808, just nine years after Goya offered the set of prints for sale, the conservative diplomat Joseph de Maistre, writing from Moscow, described it as "a book of English-style caricatures on Spanish subjects."[2] At about the same time, another French commentator likened the *Caprichos* to the social satire of Henry William Bunbury and William Hogarth, who were at the time two of the most highly regarded of the many English artists who worked in this genre.[3]

These writers were of course only able to compare the *Caprichos* with English caricature because it was a familiar type that was easily categorized. This was due to its widespread dissemination on the Continent during the second half of the eighteenth century. The combined factors of the remarkable growth in the quantity of the English caricatures, and the efforts of print dealers to market them abroad, made it possible for them to achieve an international popu-

larity. It also led to the production of foreign copies and, in the case of Goya, to a powerful and disturbing reinterpretation of the genre.

The first English prints of any category to secure an extensive foreign market were those of William Hogarth.[4] A good example of how this market was both targeted and expanded is provided by the volumes of Hogarth's work that the printseller Robert Sayer prepared specially for exportation in 1768 by furnishing them with title pages in French.[5] Volumes of his work also found their way to Spain, and were almost certainly known to Goya. Goya's colleague, the painter Luis Paret y Alcázar (1746-99), owned a volume of Hogarth's engravings by 1787,[6] and another seems to have figured in the extensive print collection of Goya's patron Sebastián Martínez.[7]

Hogarth's work was also disseminated through the proliferation of copies—legitimate and unauthorized—of his most popular images. These were produced both during and after the artist's lifetime. The resulting multiplication of certain works conferred upon them a stamp of approval, as does the repeated photographic

reproduction of certain works of art today. Such images inevitably became models for artists of the following generations. For example, the stock image of a group of men seated around a table, which appeared in seemingly endless variations from the 1730s to well into the nineteenth century (nos. 12, 19-22 and 50, and figs. 7, 27 and 39), and in the work of Goya (no. 18, and fig. 11), is traceable to what was probably Hogarth's most famous engraving, *A Midnight Modern Conversation* of 1733 (no. 1).[8]

Published just two years before the signing into law of the only somewhat effective Copyright Act (which was conceived of by Hogarth himself as a protection against the plagiarism of his prints), *A Midnight Modern Conversation* was soon pirated in England by Elisha Kirkall (no. 2). Perhaps to deflect accusations of plagiarism, Kirkall printed the copy in mezzotint rather than in Hogarth's usual combination of engraving and etching. In addition, the title was slightly changed (reading *A Modern Midnight Conversation*), the image is in reverse, and the lines of verse inscribed under the title are entirely distinct from Hogarth's.

Several other copies of the print were also made, as eighteenth century admirers of Hogarth's prints were well aware.[9] The German physicist and satirist Georg Christoph Lichtenberg, who had visited England in the 1770s, and had a profound interest in Hogarth's imagery, pointed out in his extensive study of the artist's work (published in the 1780s and 1790s) that *A Midnight Modern Conversation* was one of the Hogarth's best-known works in both England and Germany, and wrote, "I myself have found the original engravings in places where works of this kind are not usually met with, and there are a great many copies of them in existence."[10]

Hogarth's images were also disseminated through illustrations that were made to accompany books about his work. Lichtenberg himself had hired the engraver Ernst Riepenhausen to produce an engraved reproduction of *A Midnight Modern Conversation* (no. 3a) (as well as of other prints) to accompany his publication of commentaries on Hogarth's imagery (no. 3b).[11] Riepenhausen's version of the print, published in 1794, includes titles inscribed on the plate in both English and French, an indication that Lichtenberg, like printsellers in London, intended to export his work.

English and French titles also appear under the etching of *A Midnight Modern Conversation* that was included in the Vien-nese edition of Lichtenberg's commentaries (no. 4). The French title, *Les buveurs de Ponche (The Punch Drinkers)*, catered to foreign viewers of the print by being more obviously descriptive of the scene depicted than was Hogarth's own title. The revised title also would have been appealing to the non-English audience because it homed in on a familiar stereotype of the English as excessive consumers of punch, which was thought of as an alcoholic beverage peculiar to Great Britain. Ironically, one attraction that the English caricatures had for foreigners was that they attacked the customs of Britain, the traditional rival of France and Spain.[12]

The dissemination of English satirical imagery began with but was by no means limited to the work of Hogarth, and expanded along with the genre itself. By the 1790s, printseller-publishers who made these prints their specialty were actively pursuing the foreign market. Samuel William Fores, for instance, advertised "Prints and Caricatures wholesale and for exportation."[13] The success of marketing strategies such as Fores' is suggested by the observation of a German writer, Frederick A. Wendeborn, that English "Caricature prints go . . . in great quantities over to Germany, and from thence to adjacent countries."[14]

Fores seems to have considered every possible marketing strategy. In order to attract visitors from abroad to his London shop, he publicized his large caricature exhibitions in the *New Guide for Foreigners*, which he issued in around 1790. The notice is characteristic of the exaggerated advertising ploys of the time: "To the works of Hogarth, Bunbury, Sayre, and Rowlandson," Fores boasted, "is added every other Caricature Print executed by other hands that has been published during many years, the whole forming an entire Caricature History, political and domestic of past and present Times."[15] (The implied awareness of the history of the genre would in itself make a fascinating subject of study.) Such caricature exhibitions seem to have been an invention of the 1790s, and were occasionally advertised in inscriptions on prints that were published by the shop owners—Fores' exhibition of 1794 was, for example, "just fitted up . . . in an Entire Novel Stile," while in Holland's "Exhibition Rooms may be seen the largest Collection of Caricatures in Europe."[16]

Foreign visitors to London, for their part, found the sizable assortment of merchandise that was displayed in such shops sufficiently worthy of note to discuss them in their travel writings. Goya's

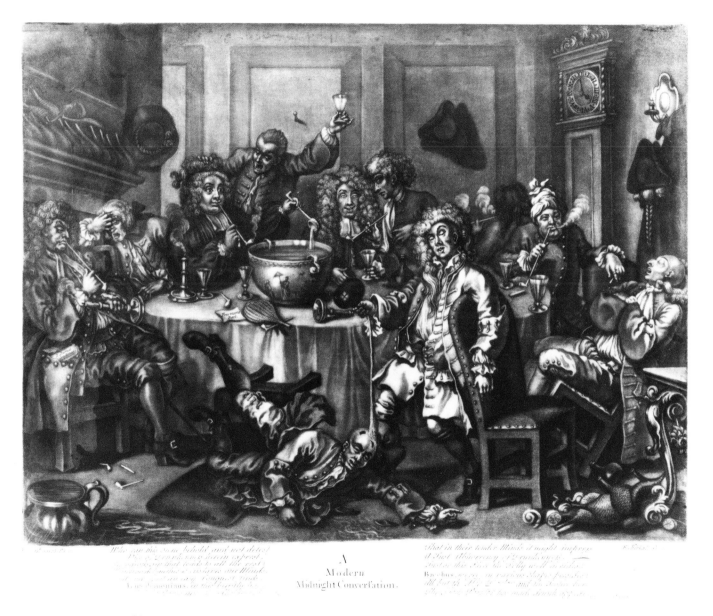

No. 2. Elisha Kirkall, after William Hogarth, *A Modern Midnight Conversation*, c. 1733, mezzotint

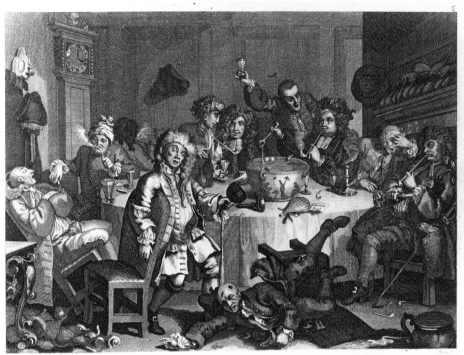

A MIDNIGHT MODERN CONVERSATION.
Le[s] buveurs de Ponche.

No. 3a. Ernst Riepenhausen, after William Hogarth, *A Midnight Modern Conversation / Le[s] buveurs de Ponche (The Punch Drinkers)*, plate 2 of a bound volume of 7 engravings made to accompany Georg Christoph Lichtenberg, *Ausfürliche Erklärung der hogarthischen Kupferstiche*, I, Göttingen, 1794, engraving

No. 3b. Georg Christoph Lichtenberg, *Ausfürliche Erklärung der hogarthischen Kupferstiche*, I, Göttingen, page 81, 1794, letterpress

friend, the playwright Leandro Fernández de Moratín, who spent one year in England during 1792 and 1793, observed in his travel notes that in London there were "shops that could be called warehouses of them [caricatures], such is their abundance."[17] He probably borrowed the term "warehouse" from inscriptions on the prints themselves, as in "at the Caracature Warehouse No 3 Piccadilly" of a print issued by Fores in 1785.[18]

Moratín's interest in English caricatures has led some scholars to suggest that Goya would have known such prints through the playwright, with whom he was in close contact during 1796 and 1797, exactly when Goya was at work on the *Caprichos*.[19] Whether Goya became familiar with the imagery through Moratín, or through the collections of Hogarth prints owned by Luis Paret or Sebastián Martínez, whom he visited in Cadiz in 1793 and 1796, or through other sources, is unknown; most likely, it was through a combination of these. His fascination with them is first manifested around 1796, when he was becoming interested in producing uncommissioned works that would give him the freedom to depict subjects of his own choosing.[20] The *Caprichos* is the first set of prints in which that desire was realized, and English satirical imagery provided him with an important model.

In a sense, the English prints symbolized freedom of expression. Visitors from the Continent were keenly aware that the satirical print was so visible a part of London life due to the fact that England, unlike the neighboring Catholic countries of France or Spain, was largely free of censorship. The German historian Johann Wolfgang von Archenholtz, who had lived in England from 1771 to 1784, pointed out in his *Picture of England* (1788) that, "It is necessary to count among the privileges of this country, the liberty to make satirical prints that ridicule the enemies of the moment."[21]

The Spanish art critic and historian Antonio Ponz, who visited England in 1783, also underscored the tolerance of the English government on this issue. In his own essay about England, he observed that "the renowned English liberty is most used, in my opinion, to write satires, and to each day put ridiculing prints, which mock the Ministry, on the doors of book shops and other stores . . ."[22] Ponz, however, felt that this liberty was abused by the satirists. "The impunity of those who engrave and publish," he wrote, "leads them to constantly put out defamatory libel and cruel satire, with which

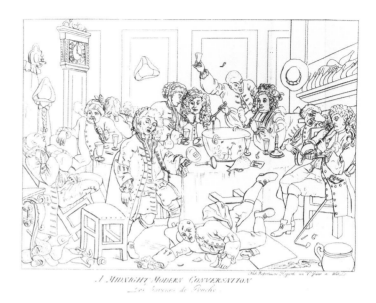

No. 4. Vincenz Raimund Grüner, after Ernst Riepenhausen, after William Hogarth, *A Midnight Modern Conversation / Les buveurs de Ponche (The Punch Drinkers)*, fold-out plate tipped in at the end of *G. C. Lichtenberg's Witzige und Launige Sittengemählde nach Hogarth*, I, Vienna, 1811, etching

9

they torment whomever they please, even the honest, the hard-working, the educated, the beneficent or those in high-ranking positions."[23] Ponz's negative response to the English caricatures is perhaps partly explained by the fact that a large subset of them were anti-Papal, and therefore would have been an affront to the Catholic viewer.[24]

More liberal-minded Spaniards, however, favored England's free speech policy. Gaspar Melchor de Jovellanos, a supporter of Goya's work, was the most notable of these thinkers. Jovellanos regarded British "liberty" as a model that he would have liked to have seen implemented in Spain, where the Inquisition still oversaw the censorship of images and texts that were deemed either obscene or sacreligious.[25]

Goya's adaptations in the *Caprichos* of the anticlerical and "obscene" imagery of the English caricatures (such as nos. 18 and 20,

and no. 39 and fig. 24) can be understood as a means—conscious or otherwise—of putting into practice this "liberty." (The same idea is also behind the fact that caricature, often also based on English models, flourished in France for the first time during the Revolution.[26]) Predictably, the endeavor caused Goya a few problems. In a letter of 1825 he recalled that the Inquisition had threatened him when he first issued the *Caprichos*. Whether this was indeed the case has been a subject of debate.[27] Documentation does exist, however, of the censorship of his work some years later. During the 1820s, the religious board *("Junta de Fé")* removed some plates from sets of the *Caprichos* that were on the market in Valencia due to their "satirical and anti-religious nature."[28] The fear of persecution is in all likeli-hood what prevented Goya from publishing during his own lifetime the subsequent print series, the *Disasters of War* (c. 1810-20), which also contained several anticlerical images.

Goya, the Print Trade, and
Anglomania in Spain

Anglomania possessed the minds of the French at the end of the eighteenth century: all the fashions, styles, manners, and even extravagances of the English, were foolishly imitated in Paris.... this vogue, like many others, was passed on to us from the French.

PEDRO ESTALA, 1805[1]

If Goya adapted various motifs of the English satirical print because he saw in it a model vehicle for exercising a belief in freedom of expression, he was attracted to the genre at least as much because it was the height of fashion. The sheer number of copies and offshoots of a print such as *A Midnight Modern Conversation*, both at home and abroad, is a good indicator of the international currency of this vogue. The foreign interest in English prints was not confined to the area of satire, however. Nor was curiosity about England limited to printmaking. From France to Russia, the literature of England was translated, its manufactured goods were imported, and "English" gardens were designed. Spain took its cue from the rest of Europe. The anglomania that spread throughout Europe during the last quarter of the eighteenth century was intimately related to the active pursuit of the export market on the part of English merchants, and to England's recently consolidated economic strength. Goya was as susceptible to this vogue as were his patrons.

In Spain, as elsewhere, the copies of English prints and emulations of English print techniques that were advertised in the newspapers with increasing frequency beginning in the early 1780s attest to their growing popularity. England was gradually replacing France as the leader in the field of printmaking. Earlier in the century, the Madrid Royal Academy of Fine Arts had routinely sent students of printmaking to Paris to master their art.[2] In the 1790s, it was possible to go to England for this purpose, as did Bartolomé Sureda Miserol (1769-1851), whose portrait Goya painted in around 1805 (National Gallery of Art, Washington, D.C.).[3] Spanish aristocrats, who earlier in the century had built up their collections primarily from French and Italian works, collected English prints in quantity for the first time.[4] It is worthy of note that the long-standing

antipathy between Great Britain and Spain had little or no bearing on this trend. Taste and marketing had the power to transgress the boundaries of politics.

England's ability to create a market for its prints was due largely to the entrepreneurial skill of certain print dealers. The most successful among these (according to his own word, but probably also in deed) was John Boydell, who aggressively pursued the foreign market. To this end, he published a two-volume catalogue in French of his print inventory,[5] and his business dealings with printsellers in Paris and Nuremberg have been documented.[6] Boydell also formed contacts in Spain. A 1787 article in the London journal *The World* boasted of the recent triumphs of the British print trade, noting that "Spain is beginning to deal largely in this commodity. A late order from Madrid to Messrs. Boydell exceeded 1,500 pounds sterling."[7] Boydell's shipment can be traced to the Madrid bookdealer Antonio Sancha. He advertised a large selection of Boydell's prints in the following year. The Duke and Duchess of Osuna, who were among Goya's most important patrons, purchased several of these from Sancha in 1787 and 1790.[8]

This newly established fashion for English prints also had an impact on Goya's commissioned work of those years, most obviously in the genre of portraiture. Portraiture, like caricature and print-making more generally, was considered to be a genre in which the English excelled, and English portrait conventions were therefore deemed worthy of emulation.[9] In Goya's painting *Duke of Alba*, of 1795 (fig. 3), the sitter's cultural sophistication is emphasized. He holds sheet music by Franz Joseph Haydn and leans on a pianoforte, possibly one of the three English pianos owned by the duke.[10] It is most peculiar that Alba wears his riding boots indoors. Riding was considered to be a specialty of the English, and this out-of-place detail was probably meant to be a sign of an English-style gentleman. The casual pose, one leg crossed over the other, which Goya used in several other portraits from around 1790 on, was in itself an allusion to the English—it is found in numerous English portraits of the second half of the eighteenth century.[11]

Goya would have been aware of this convention through prints, examples of which were in the collections of his patrons. Among the several portrait prints in Martínez's collection, for instance, is a framed portrait of the *West Family* (fig. 4);[12] the painter's son

Fig. 3. Francisco Goya, *Duke of Alba*, 1795, oil on canvas

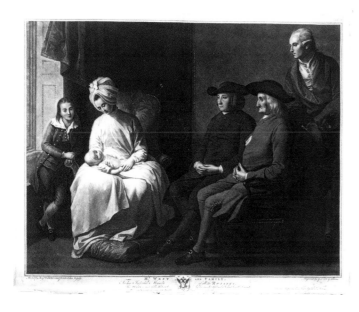

Fig. 4. George Sigmund Facius and Johann Gottlieb Facius, after Benjamin
West, *West Family*, 1779, stipple engraving

Raphael, at the far left, is shown standing in the ubiquitous crossed-leg pose that would soon be taken up by Goya. Goya certainly would have been aware of the cultural and national references that were encoded in such a pose, just as he knew the symbolism of characteristic poses of English satirical prints (see pp. 69-78).

Goya's endeavors to incorporate into his work the latest artistic trends from abroad probably reflects a desire among Spanish intellectuals to modernize the arts of their country. Spain suffered from what can be characterized as a collective self-image of lagging behind the rest of Europe in all areas, from the fine arts to industry. Among the steps taken by the Spanish government to bring the arts up to date was the establishment in 1789 of the *Calcografía Nacional*, a branch of the Madrid Royal Academy that was dedicated to the advancement of printmaking through instruction and through the publication of prints. The importation of the latest prints from England was another, less official, manifestation of the desire to modernize the arts in Spain. Goya's use of these prints as models can be viewed as an indication of his own ambition to be regarded as an artist whose work was on the cutting edge.

Goya's interest in English culture was not limited to the fine arts. He was also receptive to the recent and prevalent fascination with English literature among cultured Spaniards. One of the many English authors whose work was issued in translation during the 1780s and 1790s was Samuel Richardson, and Goya's name is on the list of subscribers to the Spanish version of Richardson's novel *Clarissa*, which appeared in installments beginning in 1794.[13] Like numerous similar translations, it was based on a French rendition. *Clarissa* was highly regarded at the time; according to a 1795 advertisement for the Spanish edition, eminent critics had rated it as "the best novel to be composed in any period, and in any language."[14]

A premium was also placed on English manufactured goods, and again this was a judgment that Goya shared with his contemporaries. Goya owned a pair of English boots, and he purchased two "very expensive" English knives for his friend Martín Zapater, which he claimed were "the best to be found" in a letter to Zapater.[15] He was especially proud of the English carriage that he had acquired in 1786, boasting to Zapater that "(there are only three like it in Madrid). . . . It has fine ironwork—gilt and polished; I tell you, even here people stop to look at it."[16] The high value that Goya attached to

these items echoed an opinion that was frequently voiced in the press.[17]

Contemporary writers were keenly aware of the role that economics had played in fostering both the development and the dissemination of English art and industry. This perception went hand in hand with the widespread stereotype of the English as commerce-oriented.[18] Moratín's visit to the Royal Academy exhibition of 1793 in London prompted the following amusingly sarcastic analysis: "The arts in England depend so much on trade and commerce, that what is not made to be sold by the dozen is not made well; it is for this reason that their prints are so excellent, and their statues so ridiculous."[19] Another writer maintained that the fine arts had only recently begun to flourish in England, a phenomenon that he attributed to the fact that the English viewed them as "parts of commerce."[20] Although overtones of envy can be heard in these statements, it is nonetheless hardly coincidental that anglomania spread throughout Europe during the last two decades of the eighteenth century, exactly at the moment when England had become the main economic power of the West.[21]

THE *CAPRICHOS* AND THE SATIRICAL PRINT IN SOCIETY:
ENTERTAINMENT AND INTERPRETATION

Who would seek will always find something. Perhaps it was precisely
that feature, so favourable to the artist, which prevented him from
writing a commentary to the work himself, although he had often
been asked to do so by his friends. . . . It certainly would not have been
to his advantage. In order that something should be thought very deep,
it should never be known how deep it is.

LICHTENBERG ON HOGARTH, 1794[1]

To entertain was the main purpose of the English caricatures. Phrases such as "Humourous and Entertaining Prints" were characteristically inscribed on the plates or on the title pages of volumes of the prints.[2] The exhibition rooms of Fores and Holland were settings in which friends could meet to view and discuss the latest display of caricatures.

Volumes of the prints were used to do the same in the privacy of one's home, where the perusal of their contents was a customary source of entertainment for guests. Volumes could even be rented; a common inscription on Fores' plates was "Folios of Caricatures lent out for the evening."[3] Through the rental system, hosts could vary their offerings, or keep them up to date. One participant in the *soirees* of the time, George Berkeley, recalled that it was routine to "get all the novelties of this kind from London as regularly as the fashionable novel or the last new ballad." He told of how they were

"the unfailing resource for the entertainment of guests in large country houses," drawing out even the shy ones, who "become social over a portfolio of ludicrous scenes in which celebrated personages have acted with more or less success."[4]

It is probable that Goya's *Caprichos* also functioned as vehicles for conversation. The Duchess of Osuna purchased four sets of the prints from Goya in early 1799,[5] and conceivably she had in mind discussing them with visitors to her country house, in emulation of the English aristocracy. The duchess's country house itself along with the accompanying irregular "English" garden, known as the *Alameda* or the *Capricho*, was built in the later 1780s and 1790s on the pattern of those of her English counterparts.[6] Goya himself spent time at the *Alameda*,[7] and several paintings by him served as decorations within the house. Among these are two scenes from the Spanish theater, perhaps conceived as Spanish variations of the

15

paintings in Boydell's famous Shakespeare Gallery.[8] Such imagery, then, would have been appropriate to the duchess's English-style house, just as the *Caprichos* was probably viewed by her as a Spanish variant of the English caricatures—a suitable addition, that is, to the library of the *Alameda*.

One way in which the duchess and other Spaniards would have been familiar with the practice of interpreting the prints as a form of socializing, was through English travellers such as the writer and art collector William Beckford. Beckford recorded in his travel diary on August 20, 1787, while he was visiting Portugal shortly before his trip to Spain, that his companions were "tumbling over" two of his folios of Hogarth's prints. One of the companions explained the prints, while another "fell into a gentle slumber," and Beckford, "into a sort of doze."[9] (In the interpretation of the satirical imagery, skill did count for something.)

The English had also established a tradition of writing interpretations of satirical prints. This practice, too, was taken up by viewers of the *Caprichos*. Several explanations of Goya's set of prints were written during his life. These commentaries, which often accompanied volumes of the prints, vary in their analyses of specific images, and scholars have attempted to discern which of them provides the interpretation that was intended by Goya. It was generally believed that, among the three most often cited of these hand-written commentaries, known as the Ayala, Biblioteca Nacional, and Prado manuscripts, the Prado variation was the one that Goya himself had composed.[10] With the discovery in recent years of numerous copies and variants of the commentaries (see no. 5), the questions of their authorship and correctness have become further complicated.[11] The commentaries are perhaps better explained as Spanish variants of the English convention of providing written explanations to satirical prints.

The most extensive of the commentaries to the English works, not surprisingly, were written to serve as roadmaps to the complex network of symbols encountered in Hogarth's images. These were issued to accompany sets of the prints, and for both native and foreign viewers of Hogarth's engravings. The commentaries that were published in languages other than English show that the custom was known abroad, and it is perhaps through these publications that Spaniards had become familiar with the practice.

Hogarth himself had hired the engraver Jean Rouquet to write commentaries in French to accompany sets of his prints. Rouquet's pamphlet, published in 1746, was sent to Germany and Italy as well as France.[12] One purpose of Rouquet's and other foreign commentaries was to explain the English customs pictured in the prints to the non-English viewer.[13] For example, Rouquet provided a lengthy description of English taverns as a kind of preamble to his discussion of plate 3 of *A Rake's Progress* (no. 49). He remarked, with obvious overtones of nationalistic chauvinism, that the scene is somewhat "crude," and that in this can be found a "marked distinction between our customs and those of the English." He then gave an account of the physical appearance of the taverns, their quantity in London, and explained that men could bring "one of the unfortunate women of which the streets of London are covered" into the place, as the Rake has done in Hogarth's engraving.[14]

Foreign commentaries to the *Caprichos* similarly served the purpose of explaining the customs of one country to the natives of another. In a manuscript written in English, for example, the explanation of the witchcraft scene depicted in plate 65 reads, "In Spain the superstitious believe that witches are carr'd by the Devil."[15] A French set of commentaries introduces the series of prints by characterizing them as satires against the superstitions and vices, especially prostitution, of the Spanish populace (no. 6). Fifteen of the plates are then identified as depictions of prostitutes in Madrid (included in this list are nos. 32 and 35, and figs. 26 and 34). The French commentary was written by a Spaniard, Juan Antonio Llorente, a

No. 5. Valentin Carderera, manuscript explanation of the *Caprichos*, *Explicacion de lo que representan . . .* , pen and brown ink

No. 6. Juan Antonio Llorente, manuscript explanation of the *Caprichos*, *Caprices de Goya*, pen and brown ink

Explicacion de lo q.e representan las ochenta estampas de los caprichos de D.n Fran.co Goya y Lucientes primer Pintor de S.M.C, grabadas por d.ho Goya al agua fuerte.

1.ª Retrato de Goya

2.ª La facilidad con q.e muchas mugeres se presentan á celebrar matrimonios esperando vivir en el con mayor libertad.

3.ª Abuso funesto de la primera educacion. Hacer q.e un niño tenga mas miedo al coco q.e á su Padre y obligarle á temer lo q.e no existe.

4.ª La negligencia, la tolerancia y el mimo hacen á los niños antojadizos, obstinados sobervios, golosos, perezosos e insufribles. Llegan á grandes y son niños todavia. Tal es el de la Kalesa.

5.ª Muchas veces se ha disputado si los hombres son peor q.e las mugeres, ó al contrario. Los vicios de unos y otros vienen de la mala educacion. Donde quiera q.e los hombres sean perversos la mugeres lo seran tambien; tan buena cabeza tiene la Señorita q.e representan en esta laminas como el Gravador q.e la esta dando conversacion, y en quanto á las viejas tan infames es la una como la otra.

6.ª El mundo es una mascara el rostro, el onje, y la voz, todo es fingido. Todo quiere aparentar lo q.e no son, todos se engañan, y nadie se conoce.

7.ª Como ha de distinguirla? Para conocer lo q.e es no basta el anteojo se necesita juicio, y practica de mundo y eso es precisamente lo q.e le falta al pobre Cavallero.

8.ª La muger q.e se cuida se sabe quando á del primer q.e la pillan y quando ya no remedio, enduo se admiran de q.e se la llevaron.

9.ª Es el fuerte mas culan y menos furioso q.e la terrivon.

10.ª Ve aqui un amante á Calderon q.e al no sobvivir Leer á su Composicion muera en brazos [...] en quanto, y la pivata q.e en temoridia. No conviene sacar la espada muy amenudo.

11.ª La cara y el trage como dicenla lo q.e ellos son.

12.ª Los dientes á horcada con quienquiera q.e los cologa un ese mendicion no se hace cosa á ennecha. La fama a q.e el bulon crea tales desatino.

13.ª Tal pescar tienen d.e capillos q.e se les mean hincan. Hacen [...] á los glaciares.

Cet ouvrage contient 80 gravures; dont la première represente la personne de l'auteur qui fit son propre portrait. Les autres 79 sont des satyres contre certaines credulités ou certains vices de la populace espagnole, plus particulièrement des femmes maquerelles, et filles de joie.

Les estampes 2, 5, 6, 15, 16, 17, 20, 22, 24, 27, 28, 31, 32, 35, 36 representent quelques scennes differentes de filles de joie, de Madrid, et de vielles femmes qui font le metier de prostituer les filles. Le petit-mot espagnol de ces estampes, et de toutes les autres sont des saillies derivées de la meditation sur le sujét de chaque gravure.

Les estampes 9, et 10 representent deux scénes tragiques de deux amants. Je ne crois pas que l'auteur eût l'intention de faire aucune alusion particuliere a des personnes vi-

former functionary of the Inquisition who had hoped to reform it, and who, during the French occupation (1808-13), contributed to its abolition. He wrote his explanatory remarks on the *Caprichos* after the occupation, while living in exile in France.[16]

More interesting than Llorente's descriptions of the individual plates is his attempt to explain to French viewers the subtleties in the relationships between word and image. He pointed out that in all the plates, "The Spanish captions . . . are witticisms, the comprehension of which is derived through a meditation on the subject matter of each print" (see no. 6). Llorente understood the complexity of Goya's work, and that its interpretation required the active participation of the viewer.

A similar position was taken by Gregorio González Azaola, a scientist by profession with broad interests who published an article on the *Caprichos* in 1811.[17] González Azaola explained that, "each person in their manner and according to their own sphere of knowledge, with more or less happy results, works out the subtle concepts contained in each of the satires."[18] Again, the emphasis is on the role of the viewer. Moreover, González Azaola plainly indicated that such interpretation was a social activity. The vices depicted in the prints, he maintained, "provide much material for discussion."[19] The prints served a purpose, then, comparable to those of Hogarth and his successors.

It even seems likely that González Azaola borrowed some of the ideas expressed in his article from the commentaries on Hogarth's work.[20] Just as the Spanish writer had observed that each person arrives at his or her own understanding of Goya's prints, so Lichtenberg noted with regard to Hogarth that, "Part of the pleasure provided by the immortal work of our artist depends, just as with the works of Nature, upon the exercise of one's own ingenuity, which must play its own part."[21] González Azaola's emphasis on the moral significance of Goya's prints, and its relation to literature—he referred to them as "80 engraved moral poems"—also has parallels in Lichtenberg's commentaries, as well as in all of the other major publications on Hogarth that were written in the eighteenth century (see no. 16). (However, as was noted previously, in the 1799 advertisement for the *Caprichos*, the word "moral" is nowhere to be found.) The Spaniard, further, maintained that the intelligent viewer of the *Caprichos* recognized that each plate "contained a certain mystery,"[22] a quality that Lichtenberg had also claimed for Hogarth's work when he philosophized that, "In order that something should be thought very deep, it should never be known how deep it is."

Published commentaries on the English prints served purposes other than the interpretation of the specific symbols and overall messages. These were also applied to Goya's *Caprichos*. One standard function of the commentaries was to identify, or at least to speculate about the identities of the persons pictured in the prints. The naming of the various individuals in Hogarth's *A Midnight Modern Conversation* (no. 1) in particular was a favorite subject of discussion. Writing in 1768, John Trusler pointed out that Hogarth in this instance did depict specific persons in a specific club. He then explained that, for the sake of decorum, since some of said individuals were still alive, he would discuss the image only in general terms, "there being many, at present, whom each character will fit."[23] Some twenty years later, John Nichols, perhaps because all of the individuals had by then been put to rest, identified some of them by name.[24]

Lichtenberg, who had read the commentaries of both Trusler and Nichols in preparing his own text, claimed that the figures in *A Midnight Modern Conversation* were portraits. "I am prepared to believe this," he explained, "since Hogarth expressly states that it is not so."[25] He was referring to the verses that Hogarth himself had inscribed below the image:

> Think not to find one *meant*
> *Resemblance* there
> We lash the *Vices* but
> the *Persons* spare

Some of the commentaries to the *Caprichos* also identified figures in a few of Goya's plates as specific persons, even though Goya, like Hogarth and perhaps even in emulation of him, denied the inclusion of portraits in his set of prints. According to the *Diario de Madrid* advertisement,

> One would be presuming too much ignorance of the fine arts on the part of the public to have to point out that in none of the compositions that make up this collection has the author intended to ridicule the particular defects of this or that person . . .[26]

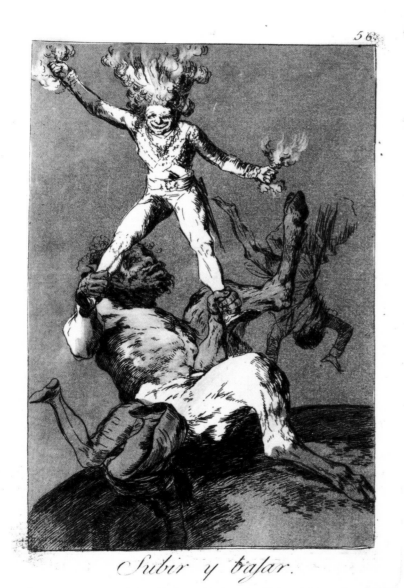

Subir y bajar.

No. 7. Francisco Goya, *Subir y bajar (To rise and to fall)*, the *Caprichos*, plate 56, *c.* 1797-98, etching and aquatint

The person who was most often identified with a particular character in the *Caprichos* was Manuel Godoy, the prime minister during the years in which Goya produced his set of prints. Godoy's rise to power through his relations with Queen María Luisa was an endless source of gossip. According to some of the commentaries on the prints, Godoy is the depraved man being hurled by a satyr (a traditional symbol of lust) in plate 56, *To rise and to fall (Subir y bajar)* (no. 7).[27]

Whether contemporary identifications of the figures in *A Midnight Modern Conversation* or in *To rise and to fall* are correct has never been adequately resolved. It may be that in each case the artist did have specific individuals in mind, and that he then generalized to make a more "universal" statement.

In this regard, Goya's aims are much closer to those of Hogarth, who like himself was a painter as well as a printmaker, than to the political caricaturists. The latter made specific individuals and events the sole focus of their work. In *The Political Balloon* (no. 8), issued anonymously in 1783, a figure in power is seated on top of the world as others plunge off it, upside down, as in Goya's *Capricho*.[28] The subject of the British print is Charles Fox's India reform bill; this is indicated through the placement of Fox on the globe just above the map of India.[29] (Fox was a favorite subject of the caricaturists during these years, and his visage is easily recognizable in the prints—see nos. 9 and 36). Goya, on the other hand, did not indicate where on the globe the satyr sits, nor are the other figures in the scene securely identifiable. He did not overtly depict specific people or events.

Goya's symbolic figure is comparable to that of another English print, *Brittannia Roused* (no. 9). In this image, etched by Rowlandson in 1784, Fox and Lord North are subjected to the wrath of Britannia, who is angered by their coalition. Again, the English print is specific in its references. In later works where the theme of these prints is carried on, such as James Gillray's depiction of England's struggle with Napoleon, *Fighting for the Dunghill* (no. 10), or Honoré Daumier's *The new Icaruses (Les nouveaux Icares)* (no. 11), which concerns the 1848 power struggle of Louis-Napoleon,[30] Fox and North are replaced by new players of the political arena. Goya understood a significant implication of the fill-in-the-blank iconography of political caricature, as the caption *To rise and to fall* implies— that those who reach the top echelons of political power are inevitably corrupt.[31]

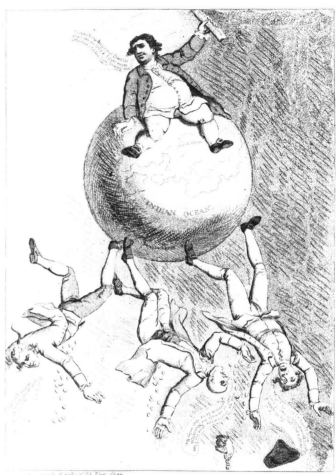

No. 8. Anonymous [Samuel Collings?], *The Political Balloon; or, the fall of East India Stock*, 1783, etching

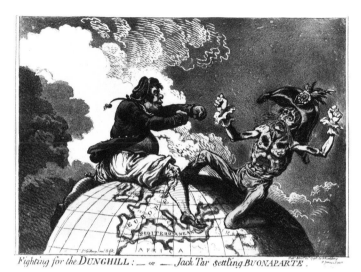

Fighting for the DUNGHILL: — or — Jack Tar settling BUONAPARTE.

No. 10. James Gillray, *Fighting for the Dunghill: or Jack Tar Settling Buonaparte*, 1798, hand-colored aquatint with etching

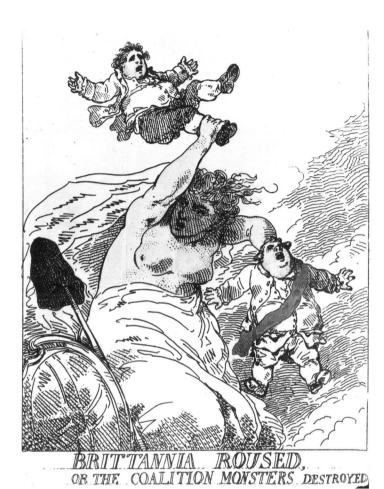

BRITTANNIA ROUSED,
OR THE COALITION MONSTERS DESTROYED

No. 9. Thomas Rowlandson, *Brittannia Roused, or the Coalition Monsters Destroyed*, 1784, hand-colored etching

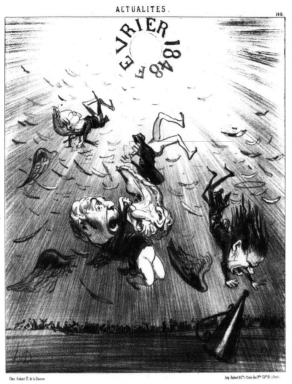

ACTUALITES.

Les nouveaux Icares.

No. 11. Honoré Daumier, *Les nouveaux Icares (The new Icaruses)*, 1850, lithograph

While some commentators on the *Caprichos* identified certain of Goya's characters as public figures (such as Godoy), others grafted alternative identities onto them. In an early nineteenth century copy of plate 20 of the *Caprichos, They already go, plucked (Ya van desplumados)* (figs. 5 and 6), a commentary was included on the plate itself, in the form of rhyming verses, which can be translated as follows:

> Look into this mirror,
> heedless lovers,
> This is how women please
> those whom they have plucked.

The verses elaborate on Goya's scene, which the copyist transformed into a specific reference to the French occupation of Spain. The plucked bird on the left was turned into Napoleon Bonaparte, while his companion is probably Napoleon's brother Joseph.[32] Goya's image was treated in exactly the same way as several English prints that were recycled during the invasion years, as for example the Spanish version of Henry William Bunbury's *A Long Story* (no. 12, and fig. 7).[33]

The inclusion of verses in the copy of *They already go, plucked* is another indication that Goya's prints were treated in much the same way as the English caricatures. Rhyming verses were often inscribed on the English prints, as in *The Evacuations* (no. 42). In some instances, the verses were handwritten on the print and served to elaborate on the significance of the image. One impression of *The Last Drop* (fig. 8), a print included in the various volumes of *Darly's Comic-Prints* that were issued during the mid-1770s, was embellished with handwritten verses in Spanish that reflect and even establish a clever dialogue with the accompanying image of a man who drinks himself to death:

> Look at this brute, shaped like a wine pouch,
> Drink his death, drop by drop.

These verses show that Spaniards had a sophisticated understanding of the English practice of interpreting caricature prints. It is reasonable to think, then, that the commentaries to the *Caprichos*, which were in one set of the prints written under the captions,[34] like the verses written on *The Last Drop*, developed out of an established English custom.

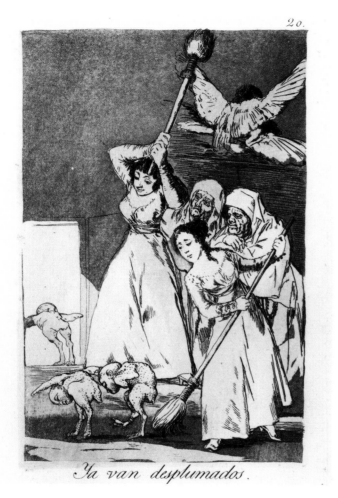

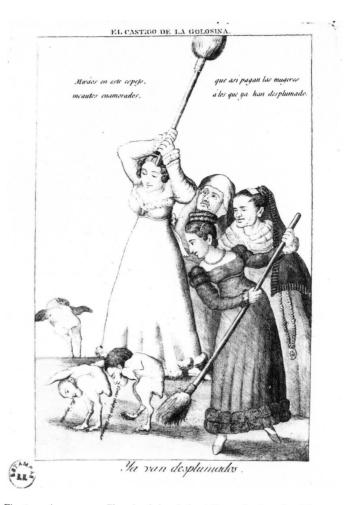

Fig. 5. Francisco Goya, *Ya van desplumados (They already go, plucked)*, the *Caprichos*, plate 20, *c.* 1797-98, aquatint and etching

Fig. 6. Anonymous, *El castigo de la golosina / Ya van desplumados (The punishment of desire / They already go, plucked)*, *c.* 1812-13, etching

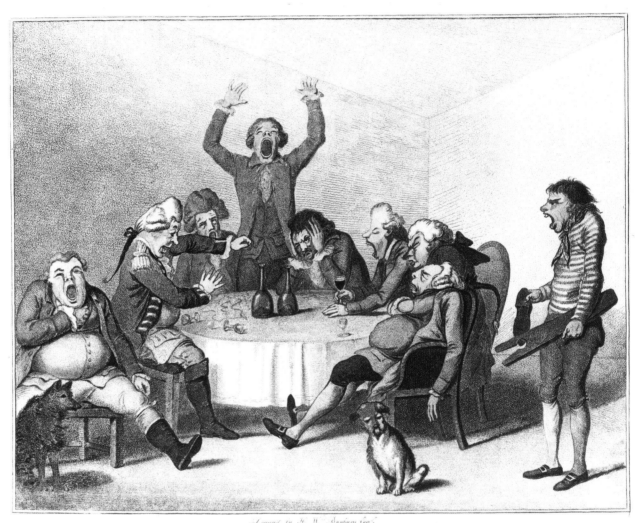

Designed by H. W. Bunbury Esq.

A LONG STORY

No. 12. Henry William Bunbury, *A Long Story*, 1802 (reissue of a print published in 1782), stipple engraving with etching

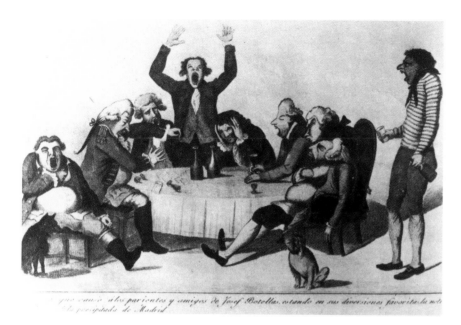

Fig. 7. Anonymous, *Sorpresa que causò á los parientes y amigos de Josef Botellas, estando en sus diversiones favoritas, la noticia de su salida precipitada de Madrid (The Surprise with which the relatives and friends of Joseph "Botellas," involved in their favorite entertainments, received the news of his sudden departure from Madrid), c.* 1813, hand-colored engraving

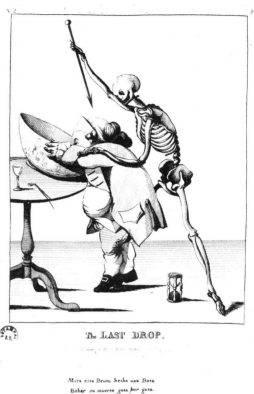

The LAST DROP.

Mira este Bruto hecho una Bota
Beber su muerte gota por gota.

Fig. 8. Anonymous [Mary or Matthew Darly?], *The Last Drop*, 1773, etching

Lichtenberg maintained in the preface to his commentaries on Hogarth's prints that there were two ways to explain the engravings: the "prosaic," which involved a detailed reading of the objects within the picture, and the "poetic," an attempt to verbally recreate the scene rather than to simply describe it. He then stated that in his own interpretations he would take the latter, more inventive approach.[35] The notion of a text that parallels the image reflects an association between satirical imagery and literature that had been firmly established by Hogarth himself, and that Goya would adapt to suit his own ends.

LITERARY ALLUSIONS IN THE ENGLISH SATIRICAL PRINT
AND IN THE *CAPRICHOS*

The author is convinced that the criticism of human error and vice
(although it seems to be a subject peculiar to eloquence and poetry)
can also be the subject of painting.

FROM THE *DIARIO DE MADRID* ADVERTISEMENT FOR THE *CAPRICHOS*, 1799[1]

The comparison of the visual arts to literature was of course hardly new or unusual. However, its association with writing that ridiculed "human error and vice"—satire, that is—was a fairly recent phenomenon, and can be traced directly to the ideas of Hogarth.

Hogarth's own likening of his work to satirical writing was well known through, for instance, two lines of verse that accompanied his celebrated engraving *A Midnight Modern Conversation* (no. 1):

Prints should be prizd as Authors should be read
Who sharply smile prevailing Folly dead

Hogarth's likening of verbal satire to its visual counterpart would become, by the 1790s, a well established convention.

It was known to the playwright Moratín, who in his notes about his trip to England had compared the humor, poses, and exaggerated gestures in the caricatures that he had seen in London to those of the theater.[2] The analogy very probably came directly from English writing on the subject, and specifically from that of Hogarth's faithful supporter, the novelist Henry Fielding.[3] The distinction that Moratín made, in continuing his discussion, between "caricature," which he viewed as similar to a "farse," and "drawing in the humorous genre," which he likened to "high comedy,"[4] is extremely close to a well known passage from the prologue to Fielding's novel *Joseph Andrews* (1742), in which he compared *caricatura* to burlesque, and *character* to the more elevated comic history painting.[5]

Fielding's remark was written in defense of Hogarth's own distinction between his work and that of the "caricaturists" who were just then becoming fashionable. This distinction was also the subject of a print that Hogarth issued in 1743, *Characters, Caricaturas*, on which he inscribed, "For a farthar Explanation of the Difference Betwixt Character & Caricatura See yᵉ Preface to Joʰ Andrews."[6] It is

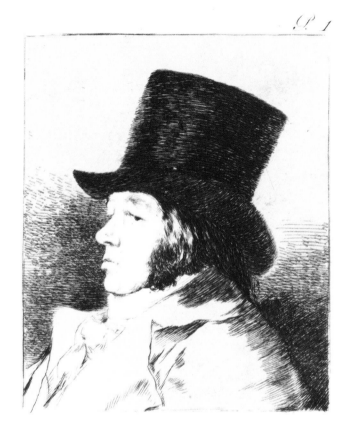

No. 13. Francisco Goya, *Franᶜᵒ Goya y Lucientes Pintor (Francisco Goya y Lucientes Painter)*, the *Caprichos*, plate 1, *c.* 1797-98, etching and aquatint

probable that Moratín took his own explanation of the distinction directly from Fielding, whom he could have read at first hand, as he had a good knowledge of the English language.[7]

Other associations between Hogarth's imagery and literature can be found in Fielding's novels, and these were known abroad through translations of his work. In Spain, translations of *Amelia* and *Tom Jones* were published in the mid-1790s. In both novels, the talents of Hogarth (along with Shakespeare) were evoked as a way to describe the vividness of the characters' physical manifestations of their emotions. In *Amelia*, the rage of Miss Matthews ("Matthieu" in the Spanish version, a telltale sign that it had been based on a French translation), as evidenced in her voice, expression, and actions were such that "Shakespeare was not able to describe more perfectly a rage, nor Hogarth paint one."[8] In *Tom Jones*, it is declared that if only Shakespeare's pen were at hand, or Hogarth's paintbrush, then perhaps the sadness, horror and trembling of the servant could be successfully "painted."[9]

Goya's own awareness, through Moratín and/or other available sources, of the customary association of satirical imagery with literature is signaled by his use of a self-portrait as the first plate of the *Caprichos* (no. 13). In literary works, a portrait of the author was of course the image that was most commonly found on the frontispiece.[10] It was undoubtedly this literary association that had led Hogarth, some five decades earlier, to engrave a self-portrait for use as a frontispiece to his volumes (no. 14). To underscore the association, Hogarth placed himself in a framed oval picture within the picture, above a stack of three books. (In the painting on which this engraving is based, the names of Milton, Shakespeare and Swift are written on the spines.[11])

Goya probably intended to establish a similar relationship to Spanish literature by quoting two lines from the satirical poem *A Arnesto* by Jovellanos for the caption of plate 2 of the *Caprichos* (fig. 9)—that is, the plate following his self-portrait.[12] The fact that this caption is two lines long sets it apart from those of the other plates, which consist of one line, and in several instances only one or a few words. The distinct nature of this caption underscores the literary connection that Goya set up in the first two plates of his book.

This connection is further emphasized by the prominence given to the masks in plate 2. The idea of combining a self-portrait

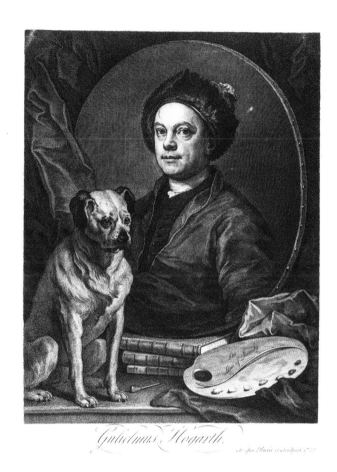

No. 14. William Hogarth, *Gulielmus Hogarth*, 1749, etching and engraving

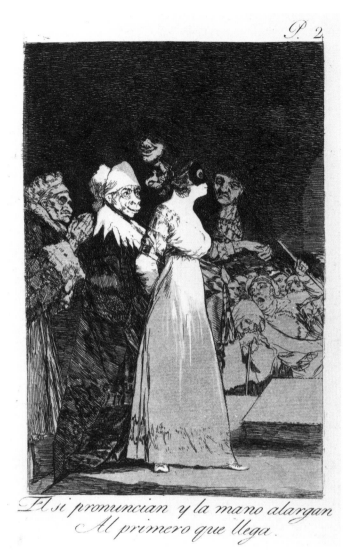

P. 2

El si pronuncian y la mano alargan Al primero que llega.

Fig. 9. Francisco Goya, *El si pronuncian y la mano alargan Al primero que llega (They say yes and give their hand to the first who takes it)*, the *Caprichos*, plate 2, *c.* 1797-98, etching and aquatint

with a mask to indicate the satirical artist's area of specialization had again been developed by Hogarth. He had designated a mask as the attribute of the Comic Muse in a self-portrait that he engraved in 1758 for use, like his earlier self-portrait, as a frontispiece to collections of his work.[13] The association with the traditional theatrical symbol of comedy is obvious. This idea was reinterpreted some years later, in 1769, by Thomas Patch, a caricaturist who lived in Italy and who also used a self-portrait as a frontispiece to his collection of etched caricatures of people whom he knew (no. 15). Patch is here seen measuring a mask, an operation that denotes the act of drawing caricatures. His mask has the face of a satyr, perhaps a play on "satire."[14]

A more general association with literature is evident in the book format of both Hogarth's and Patch's work. Again, Goya probably took his cue from the English artists. From Hogarth onward, English satirical prints were customarily sold in collections that were bound by either the publisher or the purchaser. In 1799, when Goya first advertised the *Caprichos*, he offered only the complete set of eighty prints, which could then be bound by the owner (fig. 10).[15] The advertisement makes no mention of the sale of individual plates from the series, a deviation from the standard procedure for selling prints in Spain.[16]

London printseller-publishers, however, routinely sold bound volumes of satirical prints. Hogarth had established this practice in 1736, and continued it until his death in 1764,[17] after which his wife sold the volumes.[18] In the 1790s, the enterprising John Boydell, who had purchased Hogarth's plates in 1789, marketed three editions of the artist's work in volumes (see nos. 16 and 17).[19]

The book format was adapted by publishers of caricatures beginning in the 1750s. During the 1780s and 1790s, when the satirical print reached new levels of popularity, phrases such as "Books of Caracaturs" were routinely inscribed on the prints as advertisements for these volumes.[20] William Holland ran this advertisement in 1789: "Caricature Collectors may now be supplied with the greatest variety in London of political and other humourous prints, bound in volumes and ornamented with an engraved title and a characteristic vignette."[21]

The arrangements of the prints within books of caricatures may provide an explanation for the unusual ordering of Goya's

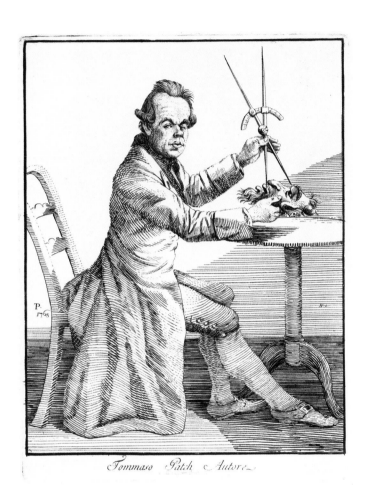

Tommaso Patch Autore

No. 15. Thomas Patch, *Tommaso Patch Autore (Thomas Patch Author)*, from
 Caricatures, 1768, etching

Fig. 10. The *Caprichos*, front cover of binding, *c.* 1830-40

THE

ORIGINAL

AND

GENUINE WORKS

OF

WILLIAM HOGARTH.

"HOGARTH may be indisputably regarded as the first Moral Painter of this
"or any other country; for, to his honour be it recorded, the almost
"invariable tendency of his *Dramatic Histories* is the promotion of Virtue,
"and diffusion of such a spirit as tends to make men Industrious,
"Humane, and Happy."

"His matchless works, of fame secure,
 "Shall live our Country's pride and boast,
"As long as Nature shall endure,
 "And only in her wreck be lost!"

See Hogarth Illustrated, in Three Vols. by J. Ireland.

LONDON:

PUBLISHED BY BOYDELL AND COMPANY, No. 90, CHEAPSIDE.

PRINTED BY W. BULMER AND CO. CLEVELAND-ROW, ST. JAMES'S.

A CATALOGUE

OF THE

ORIGINAL AND GENUINE WORKS

OF

WILLIAM HOGARTH,

CONTAINED IN THIS VOLUME

	£	s.	d.			£	s.	d.
1. Frontispiece. Portrait of Hogarth with his Dog,	0	5	0	54. The first Stage of Cruelty,				
2. Portrait of Hogarth, whole length, 1764,	0	5	0	55. The second Stage of Cruelty,				
3. The Harlot's Progress, Plate I.				56. Cruelty in Perfection,	0	12	0	
4. Ditto, Plate II.				57. The Reward of Cruelty,				
5. Ditto, Plate III.				58. The Laughing Audience,	0	1	0	
6. Ditto, Plate IV.	1	1	0	59. The Lecture,	0	1	0	
7. Ditto, Plate V.				60. Rehearsal of the Oratorio of Judith,	0	1	0	
8. Ditto, Plate VI.				61. The Company of Undertakers,	0	1	0	
9. The Rake's Progress, Plate I.				62. Characters and Caricaturas,	0	5	0	
10. Ditto, Plate II.				63. St. Paul before Felix, in the Manner of Rembrandt,	0	7	6	
11. Ditto, Plate III.				64. St. Paul, preaching before Felix,	0	7	6	
12. Ditto, Plate IV.	1	11	6	65. Ditto, with variations,	0	7	6	
13. Ditto, Plate V.				66. Moses brought to Pharaoh's Daughter,	0	1	6	
14. Ditto, Plate VI.				67. The Bench,	0	1	0	
15. Ditto, Plate VII.				68. Columbus breaking the Egg,				
16. Ditto, Plate VIII.				69. An Election Entertainment,				
17. Southwark Fair,	0	7	6	70. Canvassing for Votes,	2	2	0	
18. A Midnight Modern Conversation,	0	5	0	71. The Polling,				
19. Morning,				72. Chairing the Members,				
20. Noon,				73. France,	0	2	0	
21. Evening,	1	1	0	74. England,	0	2	0	
22. Night,				75. The Cockpit,	0	3	6	
23. Strolling Actresses dressing in a Barn,	0	7	6	76. The Five Orders of Perriwigs,	0	2	0	
24. The distrest Poet,	0	3	0	77. Enthusiasm delineated,	0	10	6	
25. The enraged Musician,	0	3	0	78. The Medley,	0	5	0	
26. Marriage à la Mode, Plate I.				79. The Times, Plate I.	0	3	0	
27. Ditto, Plate II.				80. The Times, Plate II.	0	5	0	
28. Ditto, Plate III.				81. John Wilkes, Esq.	0	1	0	
29. Ditto, Plate IV.	1	11	6	82. Charles Churchill,	0	2	6	
30. Ditto, Plate V.				83. Don Quixote, Book II. Chap. 5.				
31. Ditto, Plate VI.				84. Ditto, Book III. Chap. 2.				
32. Mr. Garrick in the character of Richard III.	0	7	6	85. Ditto, Book III. Chap. 7.				
33. Simon Lord Lovat,	0	2	6	86. Ditto, Book III. Chap. 8.	0	10	6	
34. Martin Folkes, Esq.	0	2	6	87. Ditto, Book III. Chap. 9.				
35. Dr. B. Hoadley, Bishop of Winchester,	0	2	6	88. Ditto, Book III. Chap. 13.				
36. The Industrious and Idle Apprentice, Plate I.				89. Receipt for the March to Finchley,	0	1	0	
37. Ditto, Plate II.				90. Ditto, for Moses and St. Paul,	0	1	0	
38. Ditto, Plate III.				91. The Battle of the Pictures,	0	1	6	
39. Ditto, Plate IV.				92. Receipt for the Election Prints,	0	1	0	
40. Ditto, Plate V.				93. Time smoking a Picture,	0	2	0	
41. Ditto, Plate VI.				94. Heads from the Cartoons,	0	2	0	
42. Ditto, Plate VII.	0	18	0	95. View near Chiswick,	0	1	6	
43. Ditto, Plate VIII.				96. Hymen and Cupid,	0	1	6	
44. Ditto, Plate IX.				97. The Shrimp Girl,	0	4	0	
45. Ditto, Plate X.				98. The Politician,	0	2	6	
46. Ditto, Plate XI.				99. The Good Samaritan,	0	10	6	
47. Ditto, Plate XII.				100. The Pool of Bethesda,	0	10	6	
48. The Sleeping Congregation,	0	1	6	101. Beggar's Opera,	0	10	6	
49. The Country Inn Yard,	0	1	6	102. Conquest of Mexico,	0	10	6	
50. O the Roast Beef of Old England, &c.	0	5	0	103. Sigismunda,	0	10	6	
51. The March to Finchley,	0	10	6	104. Analysis of Beauty, Plate I.	0	7	6	
52. Beer Street,	0	3	0	105. Ditto, Plate II.	0	7	6	
53. Gin Lane,	0	3	0	106. Taste in High Life,	0	10	6	
				107. The Royal Masquerade at Somerset House,	0	10	6	
				108. Finis,	0	5	0	

MESSRS. BOYDELL and Co. think it their duty, from the miserable copies of the Works of HOGARTH, that are published in this and other countries, to inform the Public, that they are the sole Proprietors of the ORIGINAL WORKS of that celebrated Artist; for which they long paid his family a large annuity:—That the Original Plates, engraved by the hand of that inimitable Artist, or under his eye, *are in very good preservation, and produce good impressions.* They also beg leave to assure the Public, that since the Plates have been in their possession, they have never allowed any Artist to profane them by a single touch, being very sensible that Hogarth's style of etching and engraving was so masterly, and expressed what he meant to convey so forcibly, that it throws all the imitators, and pretended *restorers,* at a great distance, as may be seen by comparing these miserable copies with the originals.

The ORIGINAL WORKS of HOGARTH, in one volume grand eagle folio boards, containing 108 plates, may be had of Messrs. Boydell and Co. price £21.; half bound in Russia, £23.; bound in Russia, extra, £26. 5.; *separate Prints* at the prices marked in the Catalogue.

Where also is published, HOGARTH ILLUSTRATED, by JOHN IRELAND, in three volumes Royal 8vo. price £4. 8s. 6d. in boards, containing 135 Prints, the third Edition corrected.—This Work not only explains each Print, but includes various Anecdotes of that great Artist, and of the times in which he lived.

N.B. The third Volume, compiled from Hogarth's Manuscripts, may be had separate, price £1. 16s. for the completion of sets, to accommodate those who purchased the two first volumes, before the third was published; and to purchasers of the volume of the Original Works will be sold the two first volumes of the explanations *without the Prints,* price £1. 1s. boards.

images. Books of caricatures ranged from collections on one subject, such as the ill effects of alcohol (no. 55, and fig. 28), to sets of thematically unrelated caricatures, to a combination of series and single prints, such as the collections of Hogarth's work (see no. 17). The often random ordering of the prints is comparable to the lack of a narrative unity in the *Caprichos*, in which thematically-related pairs or groups, and seemingly unrelated images are placed in sequence. Goya's unusual ordering of the plates has prompted on-going speculation about the meaning of their arrangement.[22] Understood within the context of the volumes of English satirical prints, an established type by the mid-1790s, the arrangement of the plates in the *Caprichos* seems less peculiar.

More interesting is what Goya did with this open-ended model. He positioned one image next to another within his book so that, viewed in sequence, they produce subtle associations. For instance, plate 17 (fig. 26), a depiction of a prostitute who pulls up her stocking, is followed by one of a man pulling up his pants (no. 47), while plate 25, a depiction of a child being spanked in the rear, is followed by *Now they have a seat* (no. 38), as if to play up the pun in "seat" through the juxtaposition of the two images. The comparison of Goya's prints to poetry that was made in the advertisement for the *Caprichos*, and the characterization of the work as "visual poetry," a cliché that was already established in the first decades of the nineteenth century, have their linguistic justification. If Hogarth wanted his prints to be "read" like stories, Goya wanted his to be "read" like poems.

The subject matter of both the English prints and the *Caprichos*, like their book formats, has parallels in literature. The criticism of old men pursuing marriage with or sexual favors of women who are at least half their age, for instance, was depicted by the English caricaturists (nos. 56 and 58, and fig. 32) as well as by Goya (no. 57), and was one of the most popular themes in eighteenth-century European literature.[23] The stock character of the barber was also repeatedly used in the caricatures as well as in literature. The character Marquitos in a theatrical production written by Tomás de Iriarte for the Duchess of Osuna, for example, has the role of "barber and blood-drawer."[24] This is of course a play on the closeness of the word "barber" to the word "barbarous," as is the scene of a barber whose razor cuts the flesh of his customers in a remarkably large number of caricatures.

The frequent appearance of these and numerous other subjects and character types in literature partly explains their popularity in the caricature prints. More significant, however, is the fact that they were familiar types in art because they were familiar types in life. Thus, the viewer's relationship to the depicted scene could be established immediately—the most often repeated motifs were also those that were the most ordinary and unintimidating. The images that travelled the furthest in time and place, from Hogarth to Daumier and beyond, were of the barber shop and dining room, not of the game of croquet, or of the royal palace. The artists took advantage of these everyday motifs to develop ideas and illustrate events that played against the comfort of familiarity inherent to them: the threatening, risqué, or bizarre potential of the motifs was frequently elaborated, as will become clear through a closer examination of the prints themselves.

No. 16. John Boydell, publisher, title page, *The Original and Genuine Works of William Hogarth*, London, 1790, letterpress

No. 17. John Boydell, publisher, contents page, *The Original and Genuine Works of William Hogarth*, London, 1790, letterpress

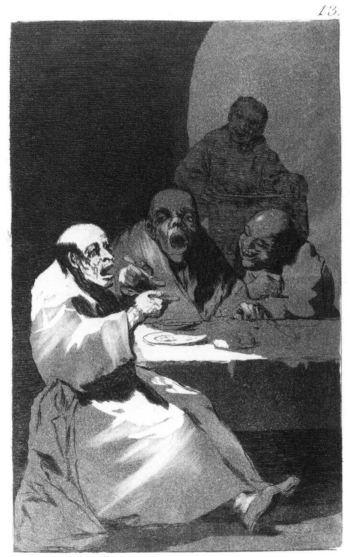

No. 18. Francisco Goya, *Estan calientes (They are hot)*,
the *Caprichos*, plate 13, *c.* 1797-98, etching and
aquatint

The *Caprichos* and Stock Motifs of the English Satirical Print

Now we behold in what unite
The Priest, the Beau, the Cit, the Bite;
Where Law and Physick join the Sword,
And Justice deigns to crown the Board:
How Midnight Modern Conversations
Mingle all Faculties and Stations.

From "The Bacchanalians: Or a Midnight Modern
Conversation. A Poem, adress'd to the Ingenious
Mr. Hogarth." Anonymous broadside, c. 1733

Artists who adapted well established motifs of English satirical imagery used them to their own ends, often focusing on a particular aspect of a motif and developing it. Goya's depiction of three monks sitting around a table in plate 13 of the *Caprichos, They are hot (Estan calientes)* (no. 18) can be traced to *A Midnight Modern Conversation* (no. 1). Goya's work is also related to a number of subsequent English prints that focused on the well-fed clergyman who stirs the punch in Hogarth's print. He is clearly the model, for instance, for the self-satisfied minister who sits in front of a punch bowl in Thomas Rowlandson's *The Parsonage* (no. 19).

The stereotypically obese clergyman is again the subject of *Fast Day!*, by Richard Newton (no. 20). In this instance, two of the shameless clerics offer a toast to the Church while another two focus their attention on the roast beef that they are about to eat. The image, and the ironic title and verses inscribed below it ("Fasting and Prayer, attending the Church Bell, That, that's the way, good Chris-

tian, to live well!") refer to a specific occasion, one of the fast days that the government had asked the population at large to observe from time to time during the war against France. The print is dated April 19, 1793, which the King had designated for a public fast in supplication for God's intervention in the armed struggle, and for the restoration of peace and prosperity.[1] The patent anti-clericism of this caricature in all likelihood reflects the revolutionary sympathies of its publisher, William Holland.[2]

The satirical depiction of clerics seated at a table endured for decades, and was not isolated to England. Daumier used the formula for his *Capucinade: Poverty Content (Capucinade: La Pauvreté Contente)* of 1851 (no. 21), which was occasioned by the recent passing of the Falloux Law for free education. Portrayed here are the capuchin fathers, who have just returned from voting. They are received by Louis Veuillot and Count Montalembert, who, like Viscount Falloux, were ultramontanes who favored free education

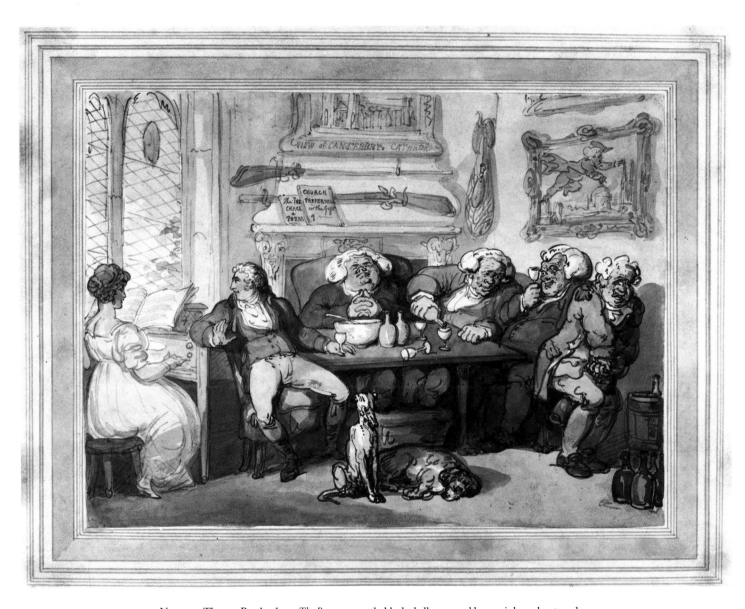

No. 19. Thomas Rowlandson, *The Parsonage*, n.d., black chalk, pen and brown ink, and watercolor

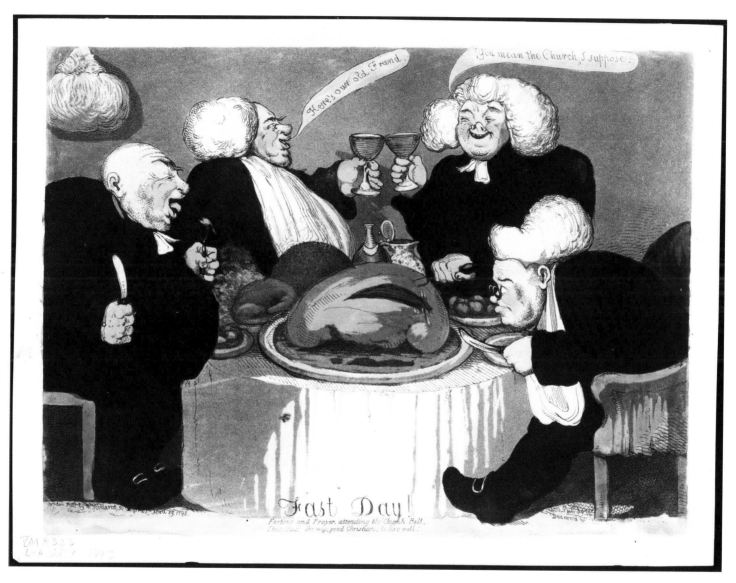

No. 20. Richard Newton, *Fast Day!*, 1793, hand-colored aquatint with etching

No. 21. Honoré Daumier, *Capucinade: La Pauvreté Contente*
 (*'Capucinade': Poverty Content*), 1851, lithograph

No. 22. Henry William Bunbury, etched by William Dickinson,
 A Chop-House, 1781, stipple engraving

but were against freedom of the press.[3] The irony of this last fact with regard to Daumier, who had been imprisoned for his satires against the previous government back in 1832, would not have been lost on the contemporary viewer of the print.

When Goya appropriated this most elastic motif of clerics seated at the dining table for plate 13 of the *Caprichos*, he typically avoided the explicit portrayal of particular people or events, in contrast to his English counterparts and their French successor. Instead, Goya established multiple allusions to more than one symptom of corruption within the church. This was achieved through the double meaning in the caption, *They are hot.*

"They" lacks a specific referent, and can denote either the food or the monks, as has often been pointed out. If the food is "hot," the implication is that the monks are such gluttons that they are compelled to eat their food before it has had a chance to cool off. If, on the other hand, it is the monks who are "hot," then the reference is to their sexual appetites.

This second implication had developed out of an emphatically risqué drawing, in which a double meaning is found in the visual rather than verbal component of the design (fig. 11). The nose of the monk on the left is also a phallus—not implied but represented graphically—and his open mouth is also an anus. In the *Capricho*, Goya repeated this last detail, but omitted the crude reference, in his rendering of the mouth of the monk who faces the viewer.

The waiter in this *Capricho* is derived from another subset of English caricatures that grew out of *A Midnight Modern Conversation* (see no. 22). In some of these prints, a human head is the dish either served by the waiter or eaten by the diners. Goya borrowed this image for another drawing that he made in the process of developing his concept for plate 13 of the *Caprichos*.[4]

The motif of the barber shop and/or hairdresser's was equally flexible. As with his depiction of monks seated around a table, when Goya adapted this image for inclusion in the *Caprichos* (no. 23), he elaborated on it to produce a variety of associations, rather than to ridicule a particular individual. The subject, predictably, had developed out of the work of Hogarth, and was taken over by the caricaturists of the following generations, frequently for the purpose of mocking a politician. Goya's own generalized satire was derived from these later images.

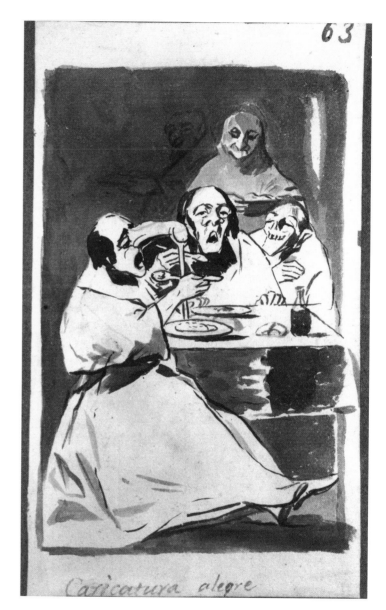

Fig. 11. Francisco Goya, *Caricatura alegre (Happy caricature)*, Album B (Madrid Album), page 63, *c.* 1796-97, indian ink wash

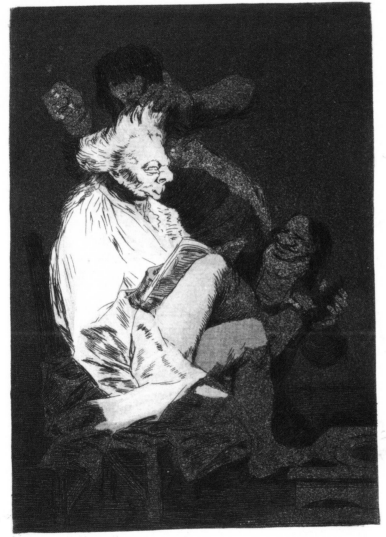

Esto si que es leer.

No. 23. Francisco Goya, *Esto si que es leer (This is certainly being able to read)*, the *Caprichos*, plate 29, *c.* 1797-98, etching and aquatint

Hogarth had included a barber who doubles as a hairdresser among the many figures in his engraving *Night*, from the series *The Four Times of Day* of 1738 (no. 24). Through the window of the building at the far left, a barber can be seen lifting up the nose of his customer, whom he has cut; this is not surprising, since his eyes are closed. The shop sign just outside of the window alludes to the scene within: "Shaving Bleeding and Teeth Drawn with a Touch." The poor customer knits his brow and clinches the arm of his chair in pain, as blood drips onto his smock.

Still, the client is hardly more virtuous than the barber. Lichtenberg explained in answer to his rhetorical question, "And why should the old gentleman at that hour of the night find it necessary to dispose of his beard?," that the man is actually in a brothel, as a sign above the one for the barber shop—"A New Bagnio"—indicates.[5] The moral of this story is of course that the customer deserved what he received.

The technique used by Hogarth of criticizing both sides of a story was reinterpreted by Goya in a most disturbing manner. In Goya's own rendition of the barber shop/hairdresser scenario, plate 29 of the *Caprichos*, *This is certainly being able to read (Esto si que es leer)* (no. 23), both the seated man who is being groomed and the valet who puts on his shoe are caricatured. The one has a cleft lip and an almost non-existent chin—indicators of his animal nature—while the other has an exaggeratedly large nose and broad grin. He laughs at the seated man, who acts as if he is reading despite the fact that his eyes are taped shut.

The laughing valet contributes in large part to the haunting effect, and to the meaning of Goya's print. He laughs at the folly of the protagonist, yet he too appears to be demented. In Hogarth's print, both the barber and his client are ridiculed, and the viewer is merely an observer of the scene. In Goya's, however, the viewer is warned not to laugh too hard, lest he or she appear too much like the demented valet.

In several of the English barber shop/hairdresser caricatures of politicians, the clients, like the man in Goya's image, have a newspaper or other reading material in hand (nos. 25 and 26, and fig. 12). Henry Fox is the subject of ridicule in *The Young Politician*, of *c.* 1771 (no. 26). Fox is attacked as an enemy of liberty: he tears up

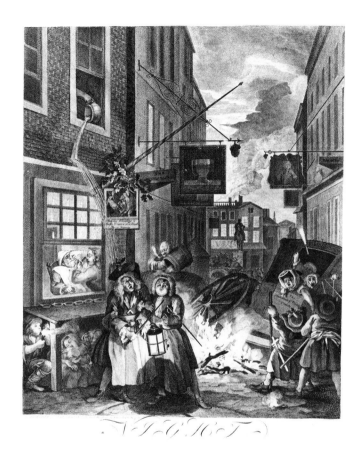

No. 24. William Hogarth, *Night, The Four Times of Day*, plate 4, 1738, etching and engraving

the Magna Charta and uses the scraps as curling papers.[6] Thus, good government is destroyed in the name of vanity.

Fox is portrayed as a fox, both as a play on his name and in reference to the cause of his vanity, which is the pursuit of the opposite sex. This objective is depicted symbolically in the statuettes of Venus and of the Three Graces that decorate the back wall. Fox was already in his late 60s when *The Young Politician* was published—hardly "young"![7] The ironic relationship between image and text is a device that Goya would apply with extraordinary power in, among other plates of the *Caprichos*, his own rendition of a politician being groomed.

In Goya's print, the caption, *This is certainly being able to read*, is an obvious contradiction of the image. This is emphasized through the placement of the figure's hand on the page, as if he is actually able to read it. It is noteworthy that both the Ayala and the Biblioteca Nacional commentaries on this print identify the subject as a government minister.[8] The association of the barber shop and hairdressers' with politicians was firmly established by the end of the eighteenth century; the caricaturist's language had become internationalized.

Hogarth's representation of a barber cutting his customer in the engraving *Night* also became a stock motif of the caricatures. The motif was effective largely because it placed the subject in a vulnerable position. Goya appropriated it for two drawings (figs. 13 and 14). So codified was the language of the caricaturist that stock themes such as this one were accompanied by stock gestures and props. As in Goya's drawings, the client often wriggles or holds up his arms and/or legs in surprise, fear, and/or pain (nos. 27 and 31, and figs. 12 and 15-18). The barber is often shown lifting the client's nose (nos. 24 and 29, and fig. 15). The client or other people in the shop frequently hold a newspaper, which sometimes functions as the distraction that causes the barber's carelessness (no. 29, and figs. 12, 15 and 19).

Stock motifs of this kind served as vehicles for elaborating stereotypes of the professions, but also of the social classes. A barber lifts the nose of his customer while being distracted by the news in *Barber* (fig. 12), designed by George Murgatroyd Woodward and etched by Thomas Rowlandson in 1799. This is one in a set of 12 prints entitled *Country Characters*, in which country bumpkins of various professions are ridiculed. Decades later, the motif was still

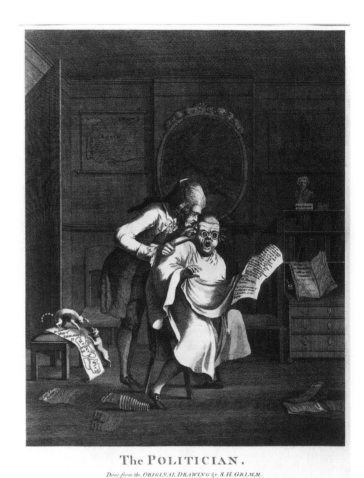

The POLITICIAN.

Done from the ORIGINAL DRAWING by S.H. GRIMM.

Printed for S.Hedge Printseller, in Henrietta Street Covent Garden. Published as the Act directs 4 May 1771.

No. 25. Anonymous, after Samuel Hieronymous Grimm, *The Politician*, 1771, engraving

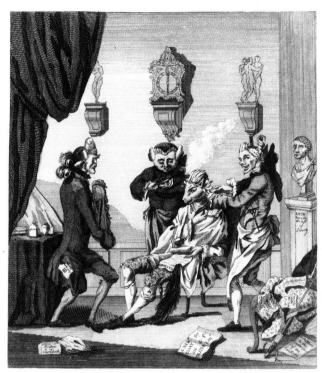

No. 26. Anonymous, *The Young Politician*, *c.* 1771, hand-colored etching and engraving

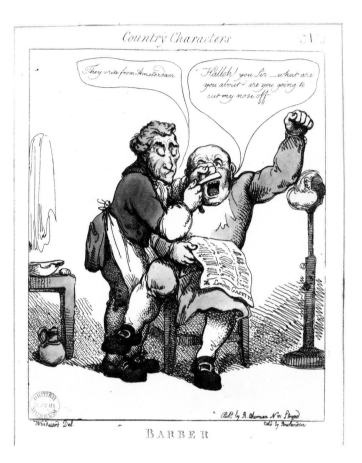

Fig. 12. George Murgatroyd Woodward, etched by Thomas Rowlandson, *Barber*, *Country Characters*, no. 3, 1799, etching

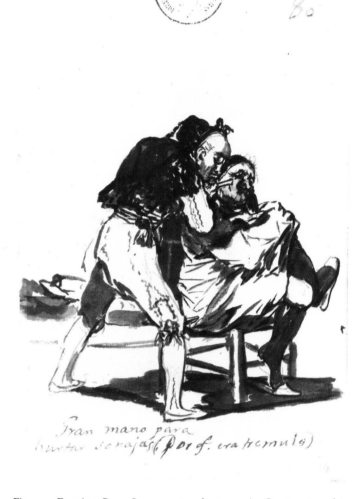

Fig. 14. Francisco Goya, *Gran mano para hurtar sonajas (Por q.ͤ era tremulo)*
(*A fine hand for robbing tambourines (Because he was trembling)*),
Album C, page 80, *c.* 1810–20, sepia wash

Fig. 13. Francisco Goya, untitled (barber), *c.* 1797, sanguine wash and red
chalk drawing

44

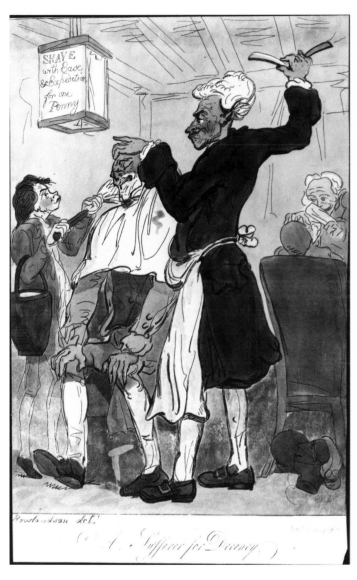

No. 27. Thomas Rowlandson, *A Sufferer for Decency*, 1789, hand-colored
etching and aquatint

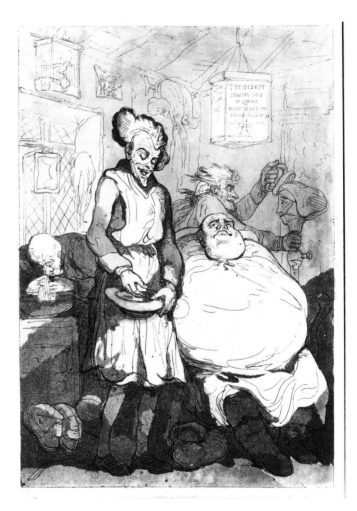

No. 28. Thomas Rowlandson, *A Penny Barber*, 1789, hand-colored etching
and aquatint (pendant to no. 27)

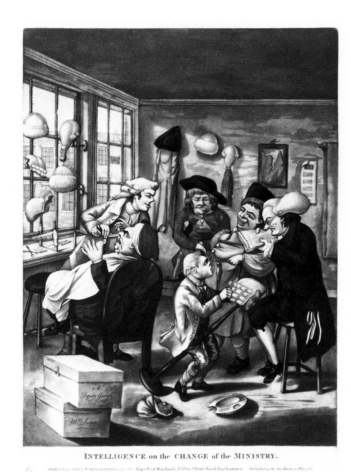

INTELLIGENCE on the CHANGE of the MINISTRY.

Fig. 15. Anonymous, *Intelligence on the Change in Ministry*, 1782,
hand-colored mezzotint

being used, as for example in Daumier's lithograph *When the news-
paper is too interesting (Quand le journal est trop interressant)* (no. 29)
from the series *Les Bons Bourgeois*. The English and French series
each targeted a particular social class.

Hogarth himself had taken great care to delineate the distinct
social classes in his engravings. Compare the clothing of the Rake
with that of the man and woman on the far right in plate 3 of *A Rake's
Progress* (no. 49), for instance. In addition, commentators on Hogarth's
work were quick to point out that his subjects were drawn from all
classes. In "The Bacchanalians," an unsigned poem about *A Mid-
night Modern Conversation*, it was observed that what united "all
Faculties and Stations" was the vice of over-drinking that Hogarth
had ridiculed in the engraving. Goya, too, was keenly aware of the
point that vice and folly were common human denominators. The
belief that all the social classes were apt subjects of ridicule was
emphasized in the 1799 advertisement for the *Caprichos*:

> the author . . . has selected as subjects that are appropriate to
> his work, from among the multitude of extravagances and
> errors that are common in all civil society, and from among the
> prejudices and falsities of the commoner, which are authorized
> by custom, ignorance or self-interest, those that he believes to
> be most apt to furnish material for ridicule.[9]

The barber shop motif endured partly because it was an
appropriate context for depictions of all classes and types. In the
political arena, the portrayal of a barber posing a threat to his client
proved to be suitable to seemingly any circumstance. Henry Wil-
liam Bunbury incorporated it into his design for *A Barbers Shop* (fig.
19), which concerns the heated campaign for the Westminster
Election of 1784. The large size of this print—the plate measures 18
x 25 1/2 inches—makes it an anomaly in the history of political
caricature. While Hogarth's prints were also large, those of the
caricaturists who succeeded him were not. It would seem that
Bunbury was attempting to move the status of caricature up from its
low position in the established hierarchy of artistic genres, just as
Hogarth had hoped that his "modern moral subjects" would be
placed on the top rung along with history painting. (Horace Wal-
pole, who avidly collected the work of Bunbury, referred to him as
"the second Hogarth.")[10] Goya also had ambitions for the genre of

No. 29. Honoré Daumier, *Quand le journal est trop interressant (When the newspaper is too interesting)*, 1846, hand-colored lithograph

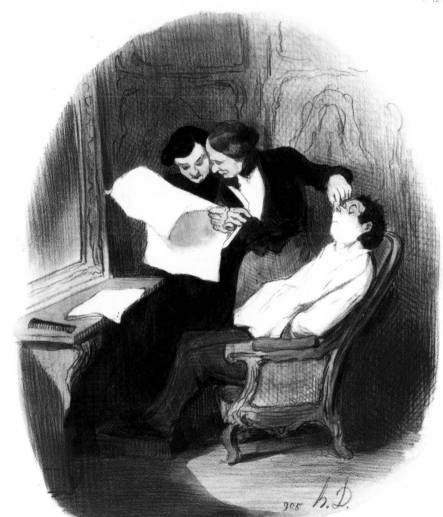

Quand le journal est trop interressant.

47

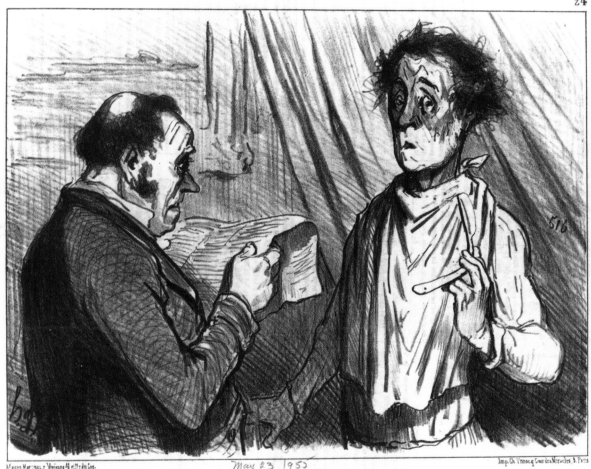

—Comment! le journal annonce que le bruit a couru à la bourse que les Russes ont franchi le Pruth!...
—Eh! bien, mossieu Panotet...quand bien même...c'est pas une raison parceque les Russes auraient commencé les hostilités pour que vous n'acheviez pas de faire votre barbe.

No. 30. Honoré Daumier, *Comment! le journal annonce que le bruit a couru à la bourse que les Russes ont franchi le Pruth! (What! The newspaper reports that Russia has passed through 'le Pruth!')*, 1853, lithograph

caricature when he incorporated it into the *Caprichos*. The caption that accompanies his self-portrait in plate 1 of the series (no. 13) identifies him as a painter rather than as a printmaker, a less prestigious title. In addition, the *Caprichos* was described in terms of painting, not printmaking, in the *Diario de Madrid* advertisement.

Another, related explanation for the unusually large dimensions of Bunbury's *A Barbers Shop* lies in the fact that the drawing for it was in the collection of Sir Joshua Reynolds, as the inscription on the plate indicates. Reynolds, as president of the Royal Academy, had enormous power when it came to matters of taste. He used this power to promote the work of Bunbury, with whom he was friendly, by allowing him to show his caricatures at the Royal Academy as an honorary exhibitor from 1770 onwards.[11] (Bunbury was not able to become an official member of the Academy because he was not a professionally-trained artist.) The drawing of *A Barbers Shop* was exhibited there in 1785, and Reynolds reportedly had stated that it was "one of the best drawings he had ever seen, and that it would be admired in every age and every country."[12] Although this prophesy turned out to be mistaken, it would have appeared to be correct during Bunbury's own lifetime, when several English as well as foreign copies of the image were made. The large size of the print certainly would have contributed to its reputation, for it would have bestowed it with an aura of importance.

As Bunbury's image moved in time and place, it was transformed by copiers to suit their own needs. In order to eliminate the timeliness of the subject, the author of an English copy of 1802 omitted the inscriptions that refer to the 1784 Election, such as the names "Hood & Wray" and "Fox" on the ribbons of the two dogs who struggle over a wig ("Whig") in the foreground.[13] In France, a copy was made in 1785, the year in which the print had originally been issued. A smaller version of this copy, entitled *The Patriotic Barber* (*Le Perruquier Patriote*—*perruquier* also signifies wigmaker, and both meanings are applicable to the image), was published in 1789. The rhyming verses that accompany it cleverly associate the three activities depicted in the print (see fig. 19) with the cause of the French Revolution, which had just gotten under way:

My heart lies with the fate of the Nation
That I have free rein, is no longer debatable:

No. 31. Anonymous, *The Patriotick Barber of New York, or the Captain in the Suds*, 1775, hand-colored mezzotint and engraving

Fig. 16. "Argus," *The Continental Shaveing Shop*, 1806, hand-colored etching

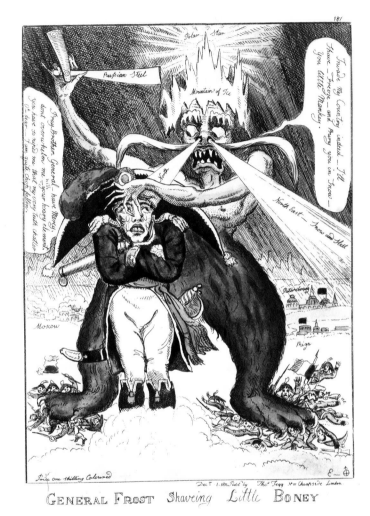

Fig. 17. Anonymous, *General Frost Shaveing Little Boney*, 1812,
hand-colored etching

I Shave the Clergy, I comb the Nobility,
I dress the Third Estate.[14]

No sooner did the ideals of the Revolution fall to pieces with the violent upheavals of the early 1790s and Napoleon Bonaparte's subsequent rise to power, than the role of the threatening barber found a new actor. Bonaparte appeared in several roughly etched barber shop scenes that chronicle the various stages of his career. In the earlier ones, he "shaves" various countries (fig. 16). With his fall from power, they "shave" him (figs. 17, 18, 20 and 21). In some instances, the fact that he was short was played up: his razor looks like a giant cleaver (fig. 16); or, he is groomed by unnaturally large mice (fig. 21).

In an offbeat variation of the barber shop theme, the barber is a woman (nos. 32-34). She is used to ridicule exaggerated advertising ploys in *Cap.tn Puff, in the Suds or the Fashionable Advertiser* of 1787 (no. 34), and in reference to political circumstances, as in a French Revolution anti-clerical print entitled *The Happy Monk Profitting from the Occasion.*[15] The sexual conceit is the focus of *The Female Shaver* (no. 33), published by Darly in 1773 and reissued in the assorted volumes of *Darly's Comic-Prints* that appeared during the 1770s. This image is blatantly erotic. The shaver sits on the lap of her customer, strokes his temple, and each of them wears a smile of sexual enjoyment. But the woman holds her razor to the man's neck. In these prints, the vulnerability of the customers who put their trust in the barber acquires a significance worthy of Freud.

In Goya's rendition of the theme (no. 32), the relationship between the barber and her client is still more complex. As in the Darly print, the man and woman eye each other with desire, but the female barber now stands, and her client coyly looks up at her; she is still in control. The caption, *She plucks him (Le descañona),* underscores the fact that he is being taken.

The presence of the two women in the background are indications that the barber shop setting is a disguise for a brothel (as in Hogarth's engraving *Night*). This is how some contemporaries interpreted the scene. Llorente listed it with the numerous representations of prostitutes in the *Caprichos* (see no. 6). According to the Biblioteca Nacional manuscript, "A cortesan shaves her naive lover, who is delighted, and she plucks every last penny from him."[16] The

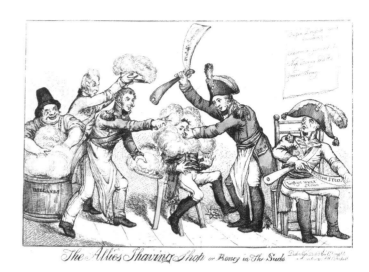

Fig. 18. Anonymous, *The Allies Shaving Shop or Boney in the Suds*, 1813, hand-colored etching

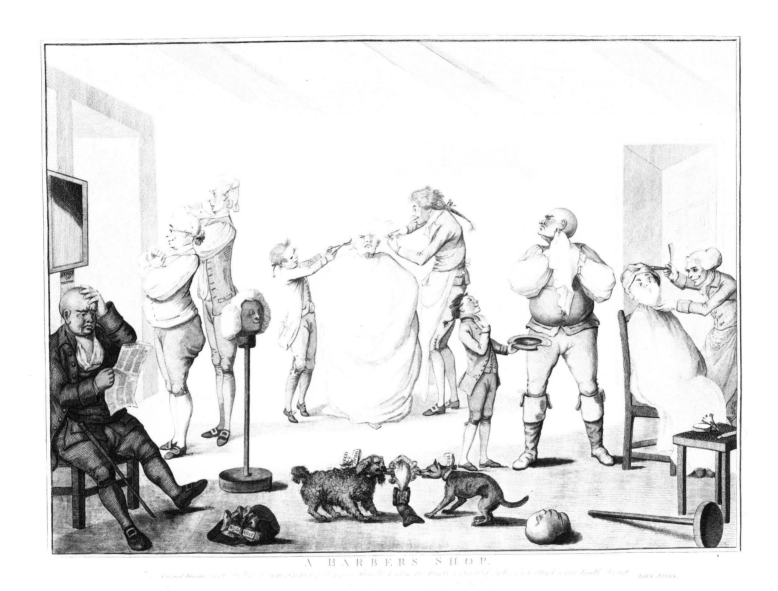

A BARBERS SHOP.

Fig. 19. Henry William Bunbury, etched by John Jones, *A Barbers Shop*, 1785, stipple engraving and etching

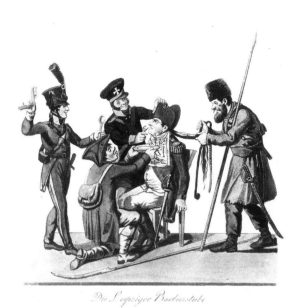

Die Leipziger Barbierstube

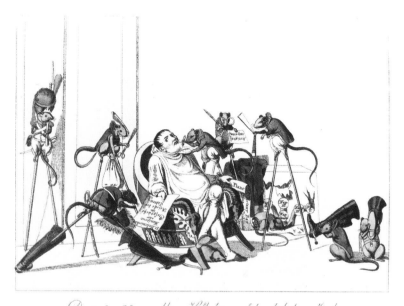

Des grossen Mannes kleine Hofhaltung auf der glückseligen Insel

Fig. 20. Christian Gottfried Heinrich Geissler, *Die Leipziger Barbierstube (The Leipzig Barbershop)*, c. 1813, hand-colored etching and aquatint

Fig. 21. Anonymous, *Des grossen Mannes kleine Hofhaltung auf der glückseligen Insel (The great man's little royal household on the blissful island)*, c. 1814, hand-colored etching

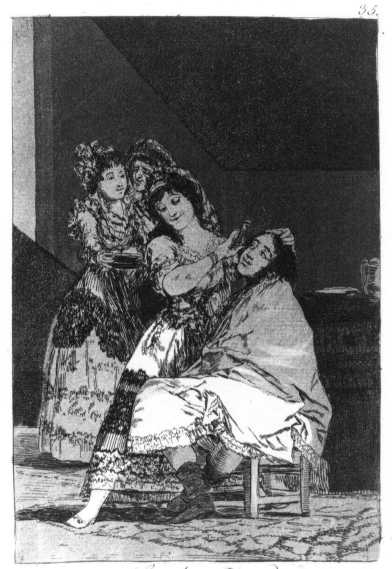

Le descañona.

No. 32. Francisco Goya, *Le descañona (She plucks him)*, the *Caprichos*, plate 35, *c.* 1797-98, etching and aquatint

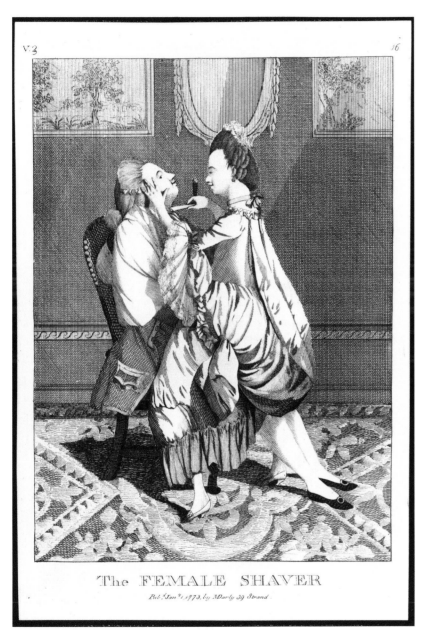

No. 34. Anonymous, *Cap.tn Puff, in the Suds, or the Fashionable Advertiser — Looseing his Wiskers,* 1787, etching

No. 33. Anonymous [Mary or Matthew Darly?], *The Female Shaver,* 1773, etching and engraving

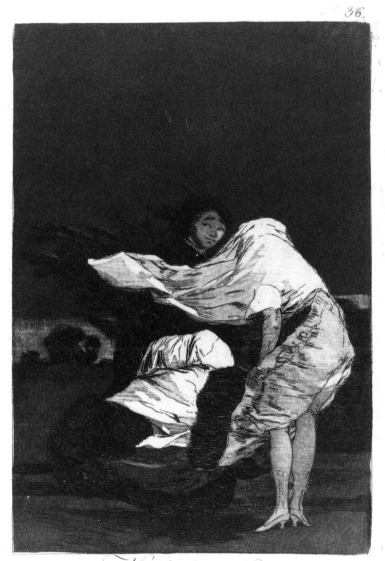

Mala noche

No. 35. Francisco Goya, *Mala noche (A bad night)*, the *Caprichos*, plate 36, *c.* 1797-98, etching and aquatint

commentary plays on the multiple meanings of "*descañonar*": to pluck, to shave against the grain, and to trick out of money.

The man's vulnerability is also multiplied through the visual language. He wears a skirt-like garment with a ruffled border rather than pants. The act of being shaved, then, seems to imply emasculation. At the same time, however, the barber seems unusually large boned for a woman. The sexual identities of the two figures are indefinite.[17]

The following plate of the *Caprichos*, *A bad night (Mala noche)* (no. 35), also concerns prostitution and human vulnerability.[18] The association of skirts blown by the wind with sexuality again has precedents in the English caricatures. Typically, in the English prints the connection is more straightforward, due to the presence of the opposite sex. In a caricature concerning the 1784 election (no. 36), Charles Fox strolls down the street with the Duchess of Devonshire, his supporter, while the "North" wind (Lord North) blows her skirt up. Edmund Burke, taking advantage of this situation, looks up her skirt and exclaims, "Heavens how happily the principels of the Sublime & Butiful are blended"—a pun on his famous treatise about the differences between the aesthetic concepts of the sublime and the beautiful.

The motif of a man looking up the wind-blown skirt of a woman was derived from earlier works, such as *A Prospect in a High Wind* of around 1747 (no. 37). "Prospect" would seem to refer to both the view afforded by the wind and the business enterprise of the woman. Goya had included blowing trees, like those seen in the English print, in one of his preparatory drawings for *A bad night* (fig. 22). In addition, the caption to the drawing, like that of its English counterpart, refers specifically to the wind: *Jesus what a Wind (Jesus que Aire)*.

In the *Capricho*, these visual and verbal indications of the wind were eliminated. Goya simplified the composition, making its allusions to sex more subtle. The related terms "blowers" and "blow" *(Soplones, Sopla)* were used, however, in plates 48 and 69 the *Caprichos*, two witchcraft scenes, where their associations with sex as well as with bodily functions were elaborated in the visual component. Goya produced a full range of significances through the associative relationships between a number of plates.

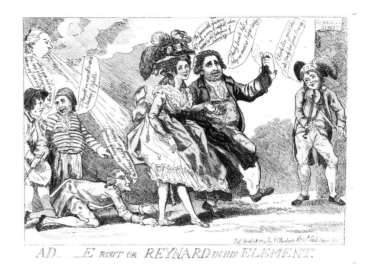

No. 36. Anonymous, *Ad E. Rout or Reynard in his Element*, 1784, hand-colored etching

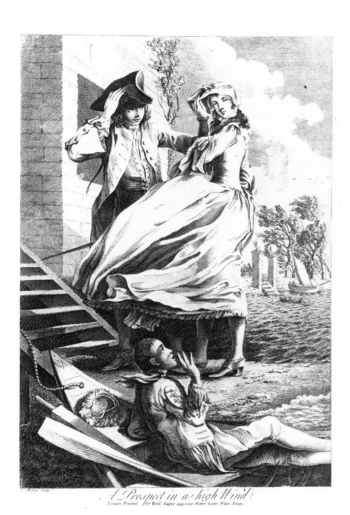

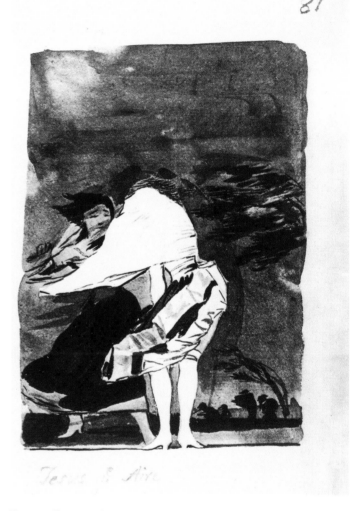

Fig. 22. Francisco Goya, *Jesus que Aire (Jesus what a Wind)*, Album B (Madrid Album), page 81, *c.* 1796-97, indian ink wash

No. 37. Charles Mosley, *A Prospect in a High Wind*, 1751, etching and engraving

58

Another theme with sexual allusions that was explored in the English prints and by Goya is a kind of modern rendition of the traditional folk image of the world turned upside down. Goya's borrowings from this tradition have often been pointed out.[19] Yet, like many other traditional motifs, this one had entered into the repertory of English satirical imagery, and Goya would have been familiar with the updated English versions. The women who wear their skirts over their heads in plate 26 of the *Caprichos, Now they have a seat (Ya tienen asiento)* (no. 38), and the man who wears his pants on his head in plate 54 of the series, *The Shamefaced (El Vergonzoso)* (no. 39), have counterparts in a pair of English prints of 1775, *The Petticoat* (fig. 23) and *The Breeches* (fig. 24).[20]

In the English versions, which are less graphic (and much less technically accomplished) than Goya's, the woman in the petticoat has large feet, suggesting that she is actually a man, while the man has small feet, suggesting that he is a woman.[21] This additional reversal of the "normal" order of things was later elaborated by, among other English artists, Thomas Rowlandson. In his *Inn Yard on Fire* (no. 40), a man in the foreground wears a petticoat over his head, while the woman on the platform at the right wears pants over hers. The circumstance of having had to flee the fire has exposed them. As in the barber imagery, the vulnerability of the subjects is the source of the humor. A similar device had been used in several anti-French Revolution caricatures in which revolutionaries were depicted without pants on; this is of course a literal interpretation of the French term for the revolutionaries, *sans culottes*.[22] Goya's understanding of exposure was more psychologically complex. In *Now they have a seat*, for example, the seated woman looks vulnerable, but the standing one appears to feel as though she is in a position of control. She is either too ignorant to realize that she has been exposed, or she has recognized that exposure has two sides—it can make a person vulnerable, but this vulnerability at the same time can be used by that person to manipulate others and therefore to gain power.

Vulnerability is again the underlying source of humor in another stock motif of the English prints that was used by Goya, that of a man armed with a clyster. This motif had the advantage of possessing built-in multiple meanings. It signifies the instrument used to administer either emetics or enemas, a syringe, and a phallus;

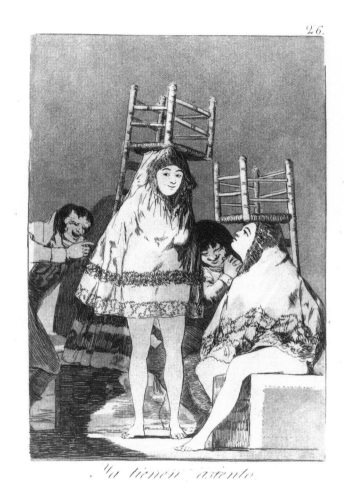

No. 38. Francisco Goya, *Ya tienen asiento (Now they have a seat)*, the *Caprichos*, plate 26, *c*. 1797-98, etching and aquatint

THE PETTICOAT.
at the Fieri maschareta.

The Breeches —
in the Fiera maschereta —

Fig. 23. Anonymous [Mary or Matthew Darly?], *The Petticoat at the Fieri Maschareta*, 1775, hand-colored etching

Fig. 24. Anonymous [Mary or Matthew Darly?], *The Breeches in the Fiera Maschereta*, 1775, hand-colored etching

No. 39. Francisco Goya, *El Vergonzoso (The Shame-faced)*, the *Caprichos*, plate 54, c. 1797-98, etching and aquatint

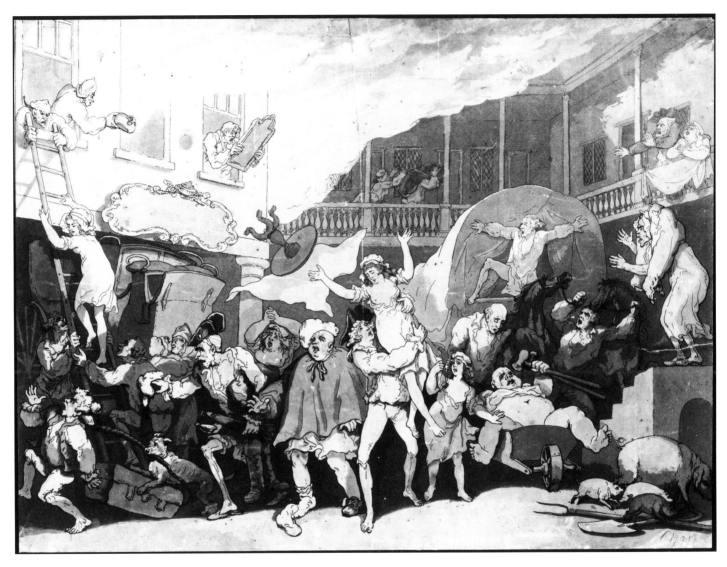

No. 40. Thomas Rowlandson, *Inn Yard on Fire*, 1791, hand-colored etching and aquatint

like the barber's razor, it was used as a weapon. All of these connotations are embedded in Goya's print, captioned *Swallow it, dog (Tragala perro)* (no. 41).

The English prints that depict men armed with clysters (which can be traced to Hogarth's illustration of 1726 of the Lilliputians giving Gulliver an enema[23]), like those of the barber shop, were usually occasioned by specific political events. In *The Evacuations* of 1762 (no. 42), Henry Fox, at the left, portrayed with the head of a Fox (as in *The Young Politician*, no. 26), points a clyster at a female allegory of Britain, who vomits the colonies that she was to return to France according to a treaty then being drawn up.[24]

Almost one hundred years later, Daumier adapted the motif of administering an emetic to a sick female, now an allegory of France, whose constitution is shown being threatened on account of the rise to power of Napoleon III (no. 43). This was one of several themes that Daumier recycled as political circumstances deemed them appropriate. In one of his early caricatures, he used it to depict the upheavals that had been brought on by the July Revolution of 1830 (no. 44).[25]

At times the clyster was used by the English artists for subjects related to medicine, so that an interplay between its literal and figurative significances was produced. *The Siege of Warwick-Castle* of 1767 (no. 45) concerns a political dispute between the Fellows of the College of Physicians at Warwick Lane in London and the government of Lord Bute (his Scottish background is indicated by the scotch plaids that the attackers wear, and Bute himself is shown in a scotch plaid in *The Evacuations*). The Scotch faction is armed with various weapons, including a syringe.[26] A tool of the medical profession is thus being used against its own trade.

This idea was adapted by Thomas Rowlandson for *Mercury and His Advocates Defeated, or Vegetable Intrenchment* of 1789 (fig. 25). On the right, a man named Isaac Swainson, who had claimed that Mercury had no medical benefits, offers in its stead a known quack remedy of the time, Velnos.[27] Among his opponents is a man armed with a clyster. Another print by Rowlandson, issued in the same year (no. 46), ridicules the underlying weakness of medicine — its inability, in the end, to save anyone.[28] A doctor at the bedside of a sick man aims his clyster not at the patient, but rather at the figure of death who enters through the window.

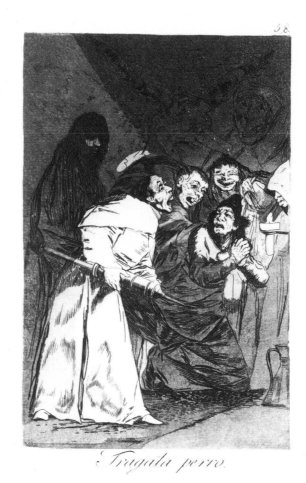

No. 41. Francisco Goya, *Tragala perro (Swallow it, dog)*, the *Caprichos*, plate 58, *c.* 1797-98, etching and aquatint

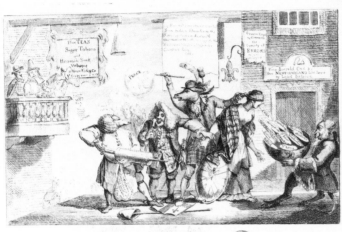

No. 42. Anonymous, *The Evacuations. or an Emetic for Old England Glorys-Tune Derry Down*, 1762, etching and engraving

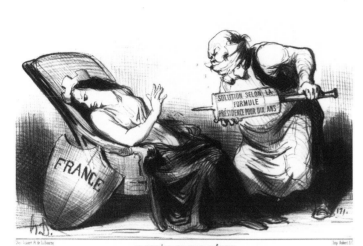

No. 43. Honoré Daumier, *Le Reméde de Mimi Véron (The Remedy of Mimi Véron)*, 1850, lithograph

No. 44. Honoré Daumier, *Monseigneur s'ils persistent nous mettrons Paris en état de siège (Monseigneur, if they persist we will put Paris in a state of siege)*, 1831, hand-colored lithograph

No. 45. Anonymous, *The Siege of Warwick-Castle; or The Battle between the Fellows & Licentiates*, 1768, etching and engraving

No. 46. Thomas Rowlandson, *The Doctor Dismissing Death*, 1785, etching and aquatint

MERCURY and his ADVOCATES DEFEATED, or VEGETABLE INTRENCHMENT

Fig. 25. Anonymous [Thomas Rowlandson?], *Mercury and his Advocates Defeated, or Vegetable Intrenchment*, 1789, hand-colored etching

In Goya's own adaptation of the clyster motif, the object is again used as a weapon, but the subject matter is wholly distinct from that of its English counterparts. The man who carries the syringe is a monk with an angry and frighteningly monstrous face.[29] The candle held by another monk, whom he faces, as well as the lamp-oil can on the ground suggest that the protagonist is bewitched (these details appear in one of the theater scenes that Goya painted for the Osuna *Alameda* at about the time he was working on the *Caprichos*, which portrays a monk who believes that he is bewitched[30]). The horned monster in the sky above him echoes his own expression, and symbolizes cuckoldry. This reference is a play on the sexual connotation of the clyster, while its use as an emetic is implied by the caption, *Swallow it, dog*. Goya transformed this stock motif of the English caricaturists into a haunting, merciless expression of the relationship between aggressor and victim.[31]

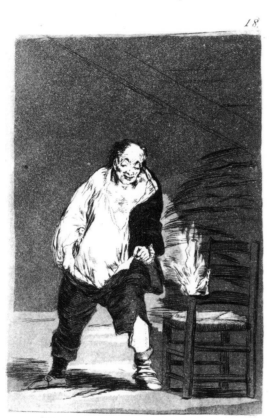

Ysele quema la Casa

No. 48. William Hogarth, *After*, 1736, etching and engraving

No. 47. Francisco Goya, *Ysele quema la Casa (And he sets the house on fire)*, the
Caprichos, plate 18, *c.* 1797-98, etching and aquatint

POSE, GESTURE, AND EXPRESSION:
SIGN LANGUAGE IN THE *CAPRICHOS*
AND IN THE SATIRICAL PRINT

Just as certain of the scenarios that were depicted in the English satirical prints were readily adapted to suit the needs of a specific artist, time, and place, so too were certain poses, gestures, and facial expressions. In addition, the meanings of these details of the human form were similarly malleable. An open mouth, for example, might signify a yawn in one context but an expression of rage in another. Goya was well versed in the sign language of the satirical print.[1] His fascinating quotations and permutations of this language become obvious through the comparison of specific poses, gestures, and physiognomic particulars found in the *Caprichos* with their numerous English counterparts.

POSE

One of the most frequently repeated stock poses of the satirical print is that in which the legs are spread apart. It was used in depictions of men, and was applied equally to standing and to seated figures. The pose denotes either sexual or alcoholic excess, and sometimes both. The two connotations are implied in plate 18 of the *Caprichos, And he sets the house on fire (Ysele quema la Casa)* (no. 47), in which a single figure holds up his pants while he takes a step forward with his legs extended.

The pose can be traced directly to an engraving by Hogarth of 1736 entitled *After* (no. 48).[2] In Hogarth's image, the man who pulls up his pants has just finished engaging in sex. To ensure that the viewer would get the point, the artist included a few revealing objects in the scene. The open book on the floor contains a quotation from Aristotle, "*Omne Animal Post Coitum Triste*" ("Every Animal Is Sad After Intercourse"), which provides an apt explanation for the gentleman's dazed look. In the picture on the wall that is illuminated by the light, Cupid stands next to a fallen rocket—a blatant and exceedingly funny illustration of the protagonist's physical state. (The picture above it, in shadow, shows Cupid launching the rocket;

this picture had been in light in the companion piece to *After*, entitled *Before*.)

In his *Capricho*, Goya apparently borrowed the pose of the gentleman in *After*, but, typically, omitted the telltale symbols, thereby producing a more suggestive and open-ended image. The differences in interpretation among the commentaries on this plate reflect the distinct meanings implied. Both the Biblioteca Nacional and the Ayala manuscripts view the figure as a lascivious old man, while according to the Prado manuscript he has had too much to drink.[3]

The sexual allusion is underscored by the relationship of this plate to the preceding one, a depiction of a prostitute (fig. 26). Just as the fire in plate 18 refers to the male sexual organ (a subtle variant of Hogarth's rocket), so the caption to plate 17, *It is well stretched (Bien tirada está)* refers to that of the female. A woman in the act of pulling up a stocking was by this time a standard symbol of the prostitute, and can be seen in numerous English as well as French prints of the eighteenth century. Hogarth included it in, among other engravings, plate 3 of *A Rake's Progress* (no. 49).

In Hogarth's engraving, Tom Rakewell, at the left, is an example of the seated variation of the sprawled leg pose. In this instance, even the expression on the face of Rakewell seems to have been adapted by Goya for his own figure.[4] Goya apparently studied the diverse figures, gestures, and expressions in Hogarth's engraving, separating and recombining them in a few plates of the *Caprichos*, which he then paired up.[5]

The Rake's demeanor, as the glass of wine in his hand indicates, is due to excessive drinking. This association was in Goya's mind when he made a preparatory drawing for his print, on which the following is inscribed: "Drunk esparto-maker who does not manage to undress and, giving his good blessings to an oil lamp, sets the house on fire."[6]

By the 1790s, the depiction of fire in combination with extended legs to indicate intoxication pervaded the caricaturists' visual language. It is the dominant motif of *The Committee of Public Vigilance (Het Committé van Algemeen Waak Zaamheid)*, plate 8 of *Hollandia Regenerata* (fig. 27). This was a widely disseminated set of 12 prints about the French Revolution, issued in 1796 with texts on the facing pages in Dutch, English and French (an Italian edition

Fig. 26. Francisco Goya, *Bien tirada está (It is well stretched)*, the *Caprichos*, plate 17, *c.* 1797-98, etching and aquatint

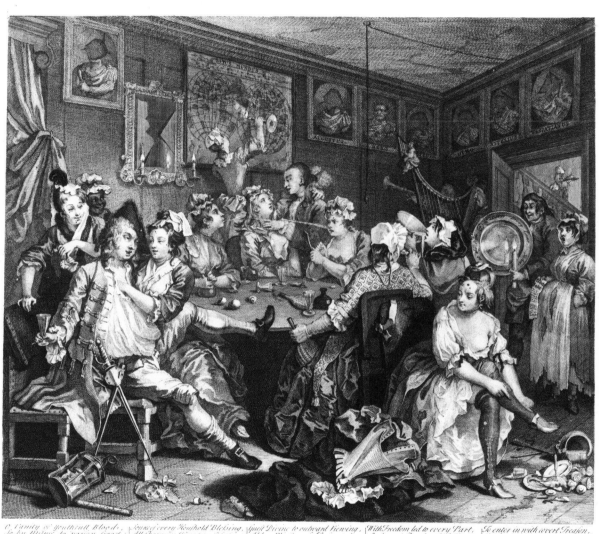

O Vanity of youthful Blood, | Source of every Houshold Blessing, | Such Divine to outward Viewing, | With Freedom led to every Part, | To enter in with covert Treason,
So by Misuse to poison Good, | All Charms in Innocence possessing, | Abler Minister of Ruin! | And secret chamber of y.º Heart, | O'erthrow the drowsy guard of Reason,
Woman, form'd for Social Love, | But turnd to Vice all Plagues above: | And Thou, no less of Gift divine, | Dost thou thy friendly Host betray, | To ransack the abandon'd Place,
Fairest Gift of Powers above! | Foe to thy Being, Foe to Love! | Sweet Potion of Misused Wine! | And Shew thy riotous gang y.º Way, | And revel there with wild Excess.

Invented Painted Engrav'd & Publishd by W.ᵐ Hogarth June y.º 24 1735 Acording to Act of Parlement.　Plate 3.

No. 49.　William Hogarth, *A Rake's Progress*, plate 3, 1735, etching and engraving

71

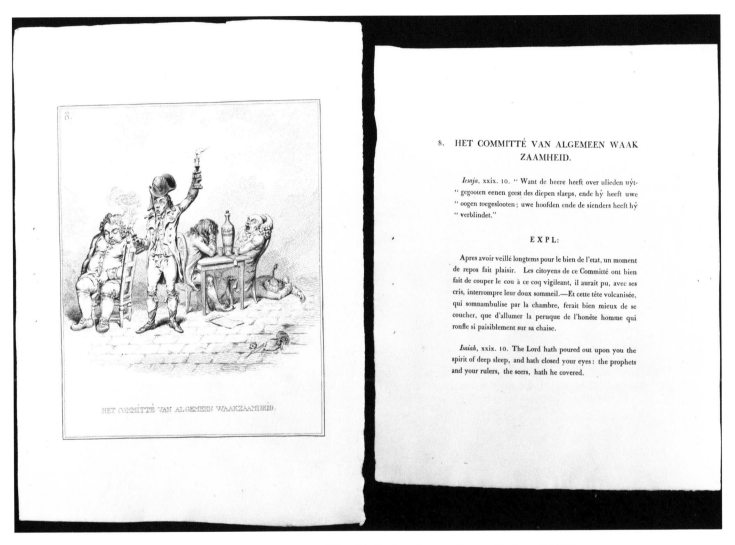

8. HET COMMITTÉ VAN ALGEMEEN WAAK
ZAAMHEID.

Iesaja, xxix. 10. " Want de heere heeft over ulieden uÿt-
" gegooten eenen geest des diepen slaeps, ende hÿ heeft uwe
" oogen toegeslooten ; uwe hoofden ende de sienders heeft hÿ
" verblindet."

E X P L :

Apres avoir veillé longtems pour le bien de l'etat, un moment
de repos fait plaisir. Les citoyens de ce Committé ont bien
fait de couper le cou à ce coq vigileant, il aurait pu, avec ses
cris, interrompre leur doux sommeil.—Et cette tête volcanisée,
qui somnambulise par la chambre, ferait bien mieux de se
coucher, que d'allumer la peruque de l'honête homme qui
ronfle si paisiblement sur sa chaise.

Isaiah, xxix. 10. The Lord hath poured out upon you the
spirit of deep sleep, and hath closed your eyes : the prophets
and your rulers, the seers, hath he covered.

Fig. 27. David Hess, etched by James Gillray (?), *Het Committe van Algemeen Waakzaamheid (The Committee of Public Vigilance)*, *Hollandia Regenerata*, plate 8 and text on facing page, 1797, etching and letterpress

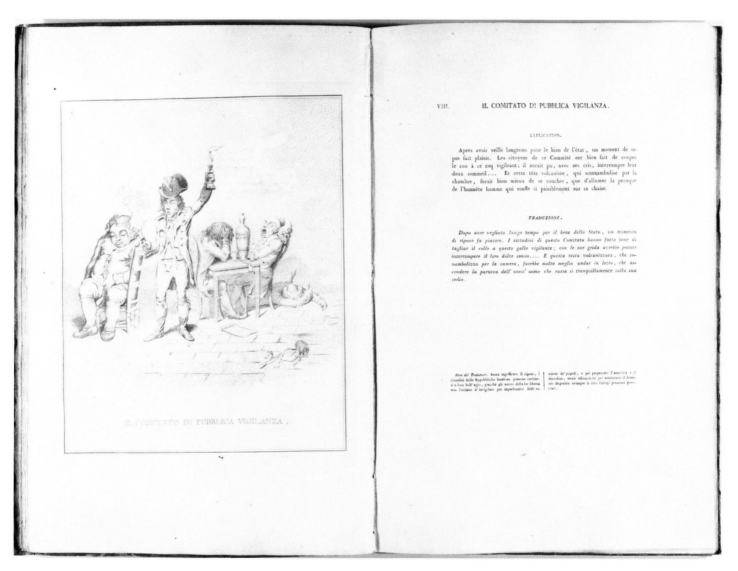

No. 50. David Hess, etched by James Gillray (?), *Il comitato di pubblica vigilanza* (*The Committee of Public Vigilance*), *La Rigenerazione dell'Olanda speechio a tutti i popoli rigenerati*, Venice, 1799, plate 8 and text on facing page, etching and letterpress

73

appeared three years later, no. 50). Here, a citizen stands with his legs spread apart and, candle in hand, sets on fire the hair of the man seated next to him. He clearly has had too much to drink (as have his companions, who have fallen asleep while seated at the table). The obvious irony of the title is underscored in the accompanying text, a quotation from *Isaiah*: "The Lord hath poured out upon you the spirit of deep sleep, and hath closed your eyes: the prophets and your rulers, the seers, hath he covered."

Predictably, the association of fire with drunkenness can be traced to Hogarth. The figure seated at the far right in *A Midnight Modern Conversation* (no. 1) sets fire to his own sleeve. It is interesting that the political reference in *Hollandia Regenerata* was already defined in Hogarth's image; according to Lichtenberg, the man, "enjoying his peace and letting others enjoy theirs . . . is about to set fire to his ruffles which will quickly ignite the neckerchief, and this will then do the same to the great hair magazine not far away . . . what politics and what a way to execute a good idea!"[7]

In another category of images, the candle and sprawled leg are combined with the indication of the time of day in the caption to portray alcoholic excess. This was another device that had its origins in *A Midnight Modern Conversation*. It was used by Bunbury for a watercolor sketch entitled *Night* (no. 51), by Rowlandson for a print of the series *Matrimonial Comforts*, entitled *Late Hours!* (no. 52), and by Daumier for *The Return Between Eleven O'Clock and Midnight (La rentrée entre onze heures et minuit)* from the series *Les Bons Bourgeois* (no. 53).

The sock that has fallen down on one leg of the man in plate 18 of the *Caprichos* is yet another detail of the extended leg pose that had entered into the vocabulary of the satirical print by way of Hogarth. As in Goya's image, it is frequently combined with a pant leg on which the buttons are open. Hogarth had included this detail in his portrayal of Tom Rakewell in plate 3 of *A Rake's Progress*. In other instances, one shoe is on, one off. Various combinations of these signs of inebriation reappear in several depictions of single figures that were designed by George Murgatroyd Woodward during the 1790s (nos. 54 and 55, and fig. 28). These works are close to Goya's image in the simplicity of their compositions as well as in the use of etching in combination with several tones of aquatint.

No. 51. Henry William Bunbury, *Night*, 1794, pencil and watercolor

No. 52. George Murgatroyd Woodward, etched by Thomas Rowlandson, *Late Hours!*, *Matrimonial Comforts*, "Sketch" 2, 1799, hand-colored etching

No. 53. Honoré Daumier, *La rentrée entre onze heures et minuit (The return home between eleven o'clock and midnight)*, 1847, hand-colored lithograph

A CHOICE SPIRIT.

BY associating with under-rate players and itinerant singers, he becomes a great Mimic, and imitates admirably the crowing of a cock, and barks with the greatest taste imaginable.

He can sing a song of his own composing in so droll a manner that he never fails keeping the table in a roar, till their voices sink by degrees, and they are no longer able to laugh, because they are no longer able either to hear or see.

He has now ascended another scale in the climax; and is acknowledged by all who know him, to be a CHOICE SPIRIT.

A Choice Spirit

He that walketh with wise men shall be wise;
but a Companion of fools shall be destroyed

Proverbs Chap. 13. Verse 20.

No. 54. George Murgatroyd Woodward, *A Choice Spirit, Gradation from a Greenhorn to a Blood . . .*,
London, 1790, plate 6 and text on facing page, Etching and aquatint, and letterpress

G.M. Woodward Delin.

May the Pleasures of the Evening bear the Morning's Reflection

Pub by Wm Holland No 50 Oxford St

MAY THE PLEASURES OF THE EVENING BEAR THE MORNING'S REFLECTION.

THIS Sentiment has much to recommend it, but like many others, it is generally mifapplied. The Vicar drinks it with the greateft hilarity, on a Saturday evening, when the enfuing morning reminds him, that inftead of enjoying the flowing bowl, he ought to have prepared a Sermon for the inftruction of his Parifhioners.—The Lawyer drinks it after a day of *full bufinefs*; and the *unenligtened* Phyfician after vifiting his Patients.—The giddy Spendthrift, after his affairs are totally deranged, with feeming unconcern gives the Sentiment, while the fmall portion of reflection left, preys upon his mind, and damps his wonted fpirits.—The Votary of Bacchus here reprefented gives it with the greateft folemnity, after his mental faculties are totally abforbed in a ftate of intoxication, a fufficient proof to fhew how blind we are to our own foibles. This Gentleman is ufually the laft in company, therefore he is placed towards the conclufion of this Volume: his whole character is comprifed in what the Bacchanalians call a *Jolly Dog*, and a ftaunch friend to the other Bottle. If this Sentiment was given with proper reflection, and a refolution to abide by its precepts, the fervice would be infinite to the community in general. The Citizen would find his beloved Spoufe come home from a Weftminfter Affembly at an early hour.

No. 55. George Murgatroyd Woodward, *May the Pleasures of the Evening bear the Morning's Reflection, Elements of Bacchus; . . .* , 1792, plate and facing page (77), aquatint with etching, and letterpress

Symptoms of Drunkenness Sketch 6.

Quite finished?

G.M.Woodward Delin London Pub by W. Holland N.º 50 Oxford Street Nov.¹.1790

Fig. 28. George Murgatroyd Woodward, *Quite finished?*, *Symptoms of Drunkenness*, "Sketch" 6, 1790, etching and aquatint

Goya had already used the motif of one sock falling down as a sign of drunkenness in a small sketch for one of his tapestry cartoons, *The Drunken Mason* of 1786 (fig. 29). He had been producing tapestry designs for the prince and princess of Asturias (who would become king and queen in 1788) since 1774. Goya's sophisticated use of a sign language of pose, gesture, and expression began to develop in these works. His vocabulary expanded with his exposure to English satirical imagery as well as to other foreign prints. It is conceivable, moreover, that he was already borrowing elements of the English prints when he composed *The Drunken Mason*. For, like the mason's fallen sock, the crying boy in the pendant to *The Drunken Mason*, entitled *The Poor at the Fountain* (Museo del Prado, Madrid), may have been derived from figures found in works such as *Noon* and *Evening*, two plates of Hogarth's series *The Four Times of Day* (1738).[8]

The Drunken Mason was never made into a full-size tapestry cartoon. Goya replaced it by an almost identical composition, *The Injured Mason* (Museo del Prado, Madrid). His patrons may have found the subject of the first design unsuitable for a tapestry that was intended to decorate the dining room of a royal palace—El Pardo—and perhaps asked that it be changed.[9] They may have also censored another of Goya's designs for a tapestry, *Winter* (fig. 30), which was intended for the same dining room. The imagery in this cartoon was apparently obscured by flakes of snow when it was made into a tapestry.[10] It is conceivable that the change was due to the fact that in the cartoon, one of the three men who trudge through the snow in the center of the composition—the one on the left—wears a skirt and sandals. This is most peculiar not only because he is a man, but also because of the season. His devious smile further suggests that he was put into the scene as a subversive element. He anticipates the protagonist in *The Shamefaced* (no. 39), who also wears a skirt and sandals. By turning to uncommissioned work, Goya was more freely able to explore, in the mediums of drawing and printmaking, the risqué but also more psychologically penetrating imagery that, as other, still earlier tapestry cartoons indicate, had long attracted him.[11]

78

Fig. 30. Francisco Goya, *Winter*, 1786-87, oil on canvas

Fig. 29. Francisco Goya, *The Drunken Mason*,
1786-87, oil on canvas

GESTURE

A symbolic language of gesture, like that of pose and costume, was already used by Goya in his tapestry cartoons. In *The Ball Game* of around 1779 (Museo del Prado, Madrid), for example, the observer of the game who is in the center of the scene presses his hand against his crotch. His hand forms a loose fist, and is positioned so that he appears to hold his sexual member (and echoes that of his other hand, in which he holds a cigar). The allusions are obvious, and have a parallel in the double meaning of the scene, a ball game.[12] Such symbolism can also be found in the English caricatures. In Thomas Rowlandson's *The Parsonage* (no. 19), the man at the far right similarly holds his fist against his crotch, and the significance of his gesture is made clear by the fact that he lustily sticks out his tongue. In the *Caprichos*, Goya explored the various significations of this fist-like gesture.

He used it for both hands of the figure in the background of *The Shamefaced* (no. 39). The expression on this man's face—the closed eyes and open mouth—can be interpreted as an indication of sexual pleasure (it is close to that of the man in *And he sets the house on fire*). The fist shape, as in the earlier tapestry cartoon, probably alludes to the act of masturbating and also to testicles.[13] The man in the *Capricho* holds his fists out, as if to make a display of himself. He is a counterpart to the protagonist of the scene, whose exhibitionism is more explicit.

Fists also contain sexual allusions in other plates of the *Caprichos*. In *This is certainly being able to read* (no. 23), the hairdresser directs his fist at the back of the customer's head. It would hardly be an over-interpretation to suppose that the object that this hairdresser seems to be preparing to insert into the man's head is phallic. Once the hairdresser's activity has become apparent, the ironic significance of the caption is amplified. Goya has cleverly and subtly fused the barber shop motif of the English caricatures with that of the world turned upside down.[14]

The fist gesture is repeated in the following plate of Goya's set of prints, *Why hide them? (Porque esconderlos?)* (fig. 31). In this instance, both the cleric in the foreground, who grasps two money bags, and the smiling man behind him and to the left, hold their hands in fists. The money bags imply greed (this is the meaning that

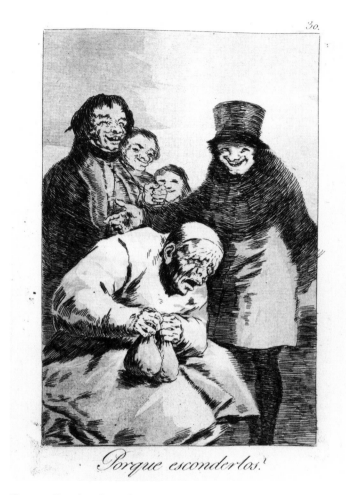

Fig. 31. Francisco Goya, *Porque esconderlos? (Why hide them?)*, the *Caprichos*, plate 30, *c.* 1797-98, etching and aquatint

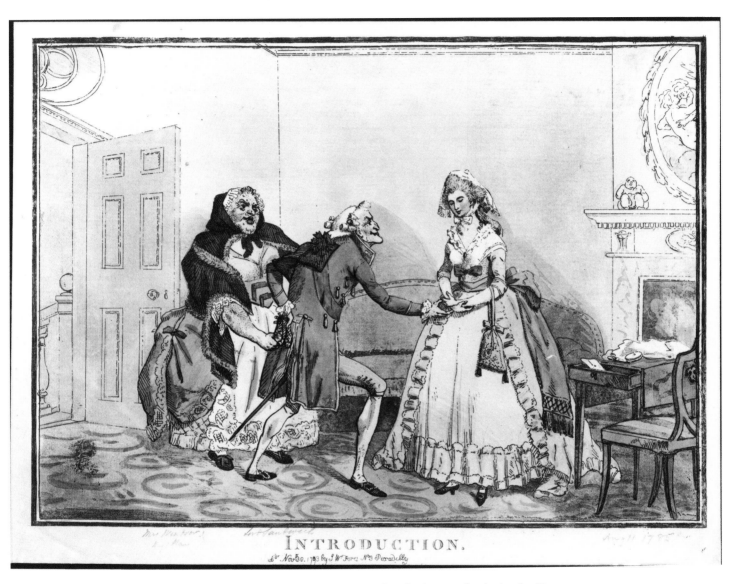

No. 56. Thomas Rowlandson (attributed to), *Introduction*, 1793, hand-colored etching

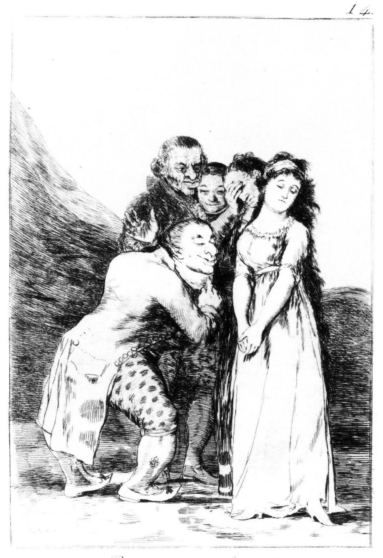

14.

Que sacrificio!

No. 57. Francisco Goya, *Que sacrificio! (What a sacrifice!)*, the *Caprichos*, plate 14, *c.* 1797-98, etching and aquatint

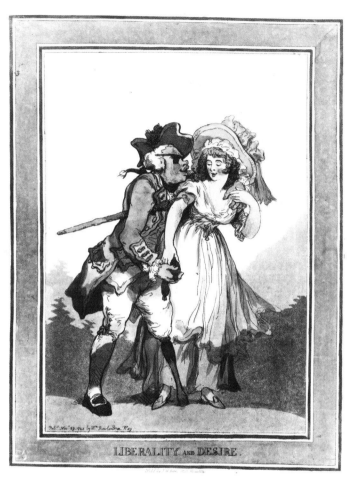

No. 58. Thomas Rowlandson, *Liberality & Desire*, 1788, hand-colored etching

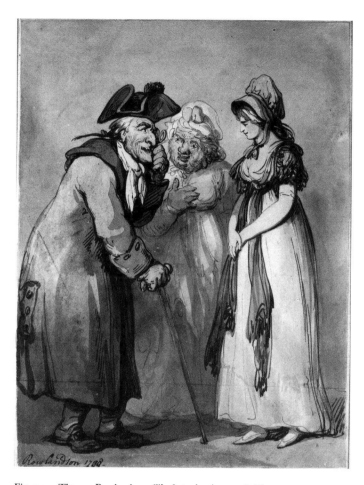

Fig. 32. Thomas Rowlandson, *The Introduction*, 1798 (?)

LADIES TRADING ON THEIR OWN BOTTOM.

Fig. 33. Anonymous [Thomas Rowlandson], *Ladies Trading on their Own Bottom*, n.d., hand-colored etching

is given in the commentaries), and sex; they double as testicles. This visual pun was used more explicitly by the English caricaturists. In an anonymous print of 1785 entitled *Introduction* (no. 56), a madame feels the money bag of an old man, who eagerly reaches out to the young woman in front of him. The reference to prostitution is still more apparent in *Ladies Trading on their Own Bottom* (fig. 33), an unsigned and undated etching in the distinctive style of Thomas Rowlandson. Here, each prostitute suggestively caresses one of the old man's money bags.

Goya associated the money bags in his own print with prostitution by sequencing it just before a depiction of a prostitute (fig. 34), the caption to which should be translated both as *Pray for her* and as *She prays for her (Ruega por ella)*. The association with the money bags is emphasized by virtue of the fact that the *Celestina*— the renowned procuress of Spanish literature—who sits next to the prostitute grasps her rosary beads with the same fist-like gesture that is seen in the previous plate. As in the placement of *It is well stretched* (in which the *Celestina's* hand is also formed into a fist) just prior to *And he sets the house on fire*, Goya expanded the significances of stock gestures and poses through subtle associations between consecutive images within his book.

As Goya began to develop his ideas for the *Caprichos* in an album of drawings, known as Album B, or the Madrid Album, and executed around 1796-97, he started to explore the hand sign language of sex in conjunction with his bizarre vision of the world turned upside down. The genesis of images such as *The Shamefaced* (no. 39) is found in these drawings. On page 58 of the album (fig. 35), one man has a phallic nose, while another has positioned his hand with the index and small finger out, a conventional symbol of cuckoldry. The drawing is the first of a group within Album B that Goya labelled "caricature." It reveals that from his earliest exploration of the use of caricature, in the Album B drawings, he associated the term with disturbing and peculiar sexual references. The same associations were also made in two other groups of drawings in Album B, "masks" and "witches." Goya's understanding of the significance of caricature, as well as of the other two categories, was inseparable from his exploration of the taboo.

Fig. 34. Francisco Goya, *Ruega por ella (Pray for her / She prays for her)*, the
Caprichos, plate 31, *c*. 1797-98, etching and aquatint

Fig. 35. Francisco Goya, *Caricat. Le pide cuentas la muger al marido
(Caricatures The wife asks her husband for an explanation)*, Album B
(Madrid Album), page 58, *c*. 1796-97, indian ink wash

EXPRESSION

Goya's unusual use of facial exaggeration in the *Caprichos* had been fully worked out as a visual language in the Album B drawings that he labelled "caricature." He had used the open mouth that appears in several plates of the series of prints (nos. 18 and 23, for instance) in three of the Album B caricature drawings (figs. 11, 36 and 37). In each case, the expression has a lewd connotation. Goya also explored the mouth/anus association in a drawing of caricature heads (fig. 38) that is generally believed to have been made at the time that he was working on the *Caprichos*. In this variation of the conflation of caricature and the theme of the world turned upside down, Goya seems to have used as a model a drawing that at the time was attributed to Leonardo da Vinci, and which was known through prints.[15]

In his prints, however, Goya's use of the open mouth is closer in form if not meaning to those seen in numerous English prints than to the "Leonardo" caricature. The meaning itself varied, depending upon the context. It functioned as a yawn in Bunbury's *A Long Story* (no. 12), in which the military officer has bored some and put to sleep other members of his audience. In a Spanish copy of Bunbury's image (fig. 7), the yawning figures, according to the caption, are friends and relatives of Joseph Bonaparte, who "in the midst of their favorite entertainments" receive the news that he has fled Madrid.[16] The yawn was at times ironic, as on the face of the "vigilant" who is about to fall asleep in *Hollandia Regenerata* (no. 50, and fig. 27). In the book *Chesterfield Travestie* of 1808 (fig. 39), it is a sign of bad table manners. Elsewhere, the open mouth signals alarm or surprise. This application of the expression was found to be especially apt for portrayals of men being groomed or shaved (see no. 25, and fig. 12, for instance). While the suggestion has been made that Goya derived his use of this expression specifically from the caricatures of James Gillray, in fact he could have known it through any number of images.[17]

Goya, like his English counterparts, caricatured figures in his prints by giving them exaggerated noses and mouths (for instance, nos. 23, 39 and 57). He also apparently adapted from them the practice of making caricature portrait drawings. The history of the caricature portrait is well known. It is believed to have developed in Italy during the late sixteenth century. In the 1730s, it became

Fig. 36. Francisco Goya, *Caricatura dlas carracas (Caricature of the carracans)*, Album B (Madrid Album), page 62, *c.* 1796-97, indian ink wash

Fig. 37. Francisco Goya, *Caricat: es dia de su Santo (Caricatures it is her [his?] Saint's day)*, Album B (Madrid Album), page 61, *c.* 1796-97, indian ink wash

Fig. 38. Francisco Goya, Caricature heads, *c.* 1798, red chalk drawing

Fig. 39. George Murgatroyd Woodward, etched by Thomas Rowlandson, *Behaviour at Table, Chesterfield Travestie; or, School for Modern Manners*, fold-out plate in bound volume, 1808, hand-colored etching

Fig. 40. Francis Grose, *Rules for Drawing Caricatures . . .* , London, 1789,
 plate I, 1788, etching

fashionable for English aristocrats who visited Italy to have a carica-
ture portrait done of them by Pier Leone Ghezzi. The practice
entered England by way of two sets of prints that Arthur Pond had
made between 1736 and 1742 after drawings by Ghezzi.[18] English
artists such as Thomas Patch (no. 15), who lived in Florence, and
Bunbury, who learned the technique from Patch, were well known
for their caricature portraits.[19]

Contemporary accounts indicate that Goya also made carica-
ture portraits of friends and acquaintances. The Countess of Merlin,
who moved to Madrid in 1803, described in her memoirs one of the
social gatherings, called *tertulias*, in which the arts and political
issues of the day were discussed. She stated that Goya joined with his
talent as a painter, "the delightful practice of making excellent

caricatures," and recalled that, "often our table was the theatre on
which he exercised his malice."[20]

In another account, Goya's friend Bartolomé José Gallardo had
apparently told the Scottish art historian William Stirling-Maxwell
that "During morning visits to his friends, he [Goya] would . . .
amuse them with caricatures, traced in an instant by his ready
finger"; the favorite target of these sketches was Manuel Godoy.[21] In
still another account, Goya was reported to have made his drawing of
caricature faces (fig. 38) at the *tertulia* of the Ninth Marquis of Santa
Cruz.[22]

Goya gave several of the characters in the *Caprichos* the fea-
tures of animals (see nos. 23 and 57). He probably drew on a
number of sources as he explored the wider possibilities of physiog-
nomy.[23] Certainly one of these was English caricature. Like the
English artists, Goya coupled human caricatures with animal-like
faces. In plate 29 (no. 23), for instance, the valet is caricatured, while
the seated man has the face of an animal, just as Henry Fox is a fox
and those who groom him are caricatured in *The Young Politician*
(no. 26). In Goya's image, however, the animal and the human
features of the client are fused; he is not simply a man who wears the
mask of an animal. This has the effect of underscoring the person's
animal nature.

In Goya's caricature of himself (fig. 1), he also emphasized his
more "primitive" side. It seems as though his curly hair, long face,
and thick lips were meant to indicate his identification with "uncul-
tured," non-Western peoples. It is curious in this regard that the line
of his face corresponds to that which Francis Grose had character-
ized as "concave" in his how-to book entitled *Rules for Drawing
Caricatures* (1789). According to Grose, faces that were "convex," as
in "figure 1" of the first plate in his book (fig. 40) signaled dignity and
grace, "whereas the concave faces ["figure 4" in the diagram], flat
snub or broken noses, always stamp a meanness and vulgarity. The
one seems to have passed through the limits of beauty, the other
never to have arrived at them."[24] Whether Goya was familiar with
such analyses of facial types, it is clear that he did not separate
himself from the figures that he ridiculed in the *Caprichos*.

~ CONCLUSION ~

He who lives among men will inevitably be vexed. If he
wishes to avoid it, he will have to go live in the mountains,
and remaining there, will realize that to live alone
is also a vexation.

PRADO COMMENTARY ON *CAPRICHO* 58 (NO. 41)[1]

If Goya ridiculed himself in his self-portrait caricature, by the same token he warned the viewer of his prints not to laugh at the vices depicted in them without taking a hard look at himself or herself. The laughing onlookers in *They are hot* (no. 18), *This is certainly being able to read* (no. 23), *Now they have a seat* (no. 38), and *Swallow it, dog* (no. 41) are terrifying rather than funny. They are critical of the scenes that they witness, but hardly appear to have the faculties required for passing sound judgment. The viewer identifies with the depicted onlookers, and does not laugh for fear of resembling them.

The English caricatures tend to be funny. The viewer is able to laugh at them because he or she is not implicated in the follies, which often involve specific individuals. Yet the viewer's laughter is likely to contain within it a dose of hypocrisy. As has often been pointed out, the popularity of works such as Hogarth's print *After* (no. 48) was due at least as much to the fact that the depiction of vice was

titillating as it was to any moral message that the imagery was intended to convey. The viewer of the image was, then, a voyeur. This reverse aspect of prints such as *After*, and its pendant, *Before*, was recognized in the eighteenth century. John Nichols felt the need to justify the existence of these two prints in his *Biographical Anecdotes of William Hogarth* (1781). He noted that Hogarth had made them at the request of a patron, and that he later regretted having done so. Nichols then explained that their existence had caused a predicament for collectors of volumes of Hogarth's work, for, "To omit them, is to mutilate the collection . . . and to display them, would be to set decency at defiance."[2] The Reverend John Trusler chose to omit the two prints from his own study of Hogarth's prints, *Hogarth Moralized* (1768), "they being of too ludicrous a nature to have a place in this work."[3]

Goya instinctively recognized the contradiction inherent to calling prints such as *After* "moralizing." The ability of this image to

titillate, as both Nichols and Trusler understood, forced viewers of the print to acknowledge a side of themselves that they perhaps would have preferred not to own up to. The *Caprichos*, on the other hand, are critical toward both vice *and* the hypocritical ridicule of it. As was stated in the advertisement for Goya's set of prints, everyone is subject to vice and error. Goya used well-established devices of English caricature, among other resources, to expose the conflicts presented by the impulses of human desire facing the rules of society, to which they are often opposed. The use of caricature to reveal the dark side of the human psyche in art is not "modern," and it did not begin in the twentieth century, nor even with Daumier in the nineteenth.[4] What seems "modern"—in the end, an arbitrary label—in the *Caprichos* to the present day viewer is simply Goya's ability to look at human nature for what it is, and to then be able to communicate the resulting observations in his art. If Goya had one overriding message to convey, it was that human nature, at its worst but also at its best, is a common denominator that unites past and present, nationalities, and classes, and that its power should never be underestimated.

NOTES

INTRODUCTION

1. The postulation that the dateline was a joke is found in the literature on Goya beginning in the 1920s, in Beruete, 1922, p. 73, and Mayer, p. 55. The dating problem is discussed in *Cartas*, pp. 226-27, note 1.

2. For an overview of the various sources for the *Caprichos* that have been suggested, see Bareau, pp. 23-41.

3. A good, concise account of the development of caricature in England during the eighteenth century is found in the introduction in Godfrey.

4. Excellent accounts of the history and technique of aquatint, as well as of other print techniques mentioned in this essay, can be found in Griffiths.

5. The advertisement is reproduced in Helman, 1963, pp. 21-22 of the illustrations. There has been much speculation about whether Goya wrote this advertisement, or whether one of his friends composed it for him. In any case, it is reasonable to assume that the ideas expressed in it are his.

THE *CAPRICHOS* AND THE DISSEMINATION OF THE ENGLISH SATIRICAL PRINT

1. Lichtenberg, p. 3.

2. Letter of January 1808 to Chevalier de Rossi. *Mémoires politiques et correspondance diplomatique de Joseph de Maistre*, ed. Albert Blanc, 2nd ed., Paris, 1859, p. 306, as quoted by Glendinning, 1977, p. 63.

3. The statement is in an anonymous manuscript commentary on the *Caprichos*, published by Lefort, p. 38, note.

4. See Alexander and Godfrey, p. 16.

5. *Les Satyres de Guillaume Hogarth . . . A Londres, chez Robert Sayer, Marchand de Cartes et d'Estampes*. On this set, see Paulson, 1965, I, p. 71.

6. "Obras de Guillermo Hogarth Pintor Inglés. 1 vol. en fol.," was among the books that Paret had requested permission to bring with him when he moved from Bilbao to Madrid in 1787. "Lista de los utiles al Estudio de Pintura de Dn. Luis Paret Academico de Merito de la Rl. de Sn. Fernando en ser.⁽ᵒ⁾ de S.M.," appended to a letter of March 26, 1787 from the Count of Floridablanca, then prime minister, to Pedro de Lerena, minister of the interior, on Paret's behalf, as published in Pardo Canalís, p. 108.

7. Among the books of prints in the 1805 inventory of Sebastián Martínez's collection is "Pint.ˢ de Horgat." *Partición Combencional*, fol. 1249r. I am grateful to Nigel Glendinning for having provided me with a copy of this inventory. "Horgat" is generally taken to be Hogarth. See Pemán, p. 57, and Glendinning, 1981, p. 244.

8. See p. 93, note 8.

9. Other copies are described in Paulson, 1965, I, p. 151.

10. Lichtenberg, p. 173. On the numerous copies of this print in England, France and Germany, see Antal, p. 206, Paulson, 1965, I, p. 151, and George, 1967, p. 43.

11. On the two editions of the commentaries issued during the 1780s and 1790s, see Lichtenberg, p. ix, and Paulson, 1965, I, p. 81.

12. On foreign copies of English prints that concerned England's weaknesses, see George, 1959, I, pp. 153-55, and Halsey, p. 811, and pp. 823-24. A Spanish copy was made of a print that criticized the taxes that English citizens were forced to pay; George, VI (1938), no. 6914, and Biblioteca Nacional, Madrid, no. 17885.

13. As cited in George, 1959, I, p. 176.

14. *A View of England Towards the Close of the Eighteenth Century*, Vol. II, London, 1791, p. 213, as cited in Bruntjen, pp. 39-40.

15. Quoted from George, 1959, I, p. 205. For an interesting study of the sophisticated advertising techniques that had developed in England by this time, see McKendrick, "George Packwood and the Commercialization of Shaving: The Art of Eighteenth-century Advertising," in McKendrick, Brewer and Plumb, pp. 146-94.

16. See, for instance, George, VII (1942), p. 94, no. 8469, and p. 130, no. 8551.

17. *Apuntaciones*, pp. 182-83.

18. George, VI (1938), p. 265, no. 6875.

19. The possibility that Goya knew of English caricature through Moratín is suggested by Helman, 1963, pp. 37-38, and is further developed by Salas, pp. 711-16. To make his case, Salas points out that Moratín's diary entries indicate that he was in close contact with Goya during 1796 and 1797, as is illustrated by Baticle, 1971.

20. Goya first expressed this interest in a letter of January 4, 1794 to Bernardo Iriarte, Vice-Protector of the Madrid Royal Academy of Fine Arts, regarding a group of uncommissioned paintings that he had made. The letter is published in Gassier and Wilson, p. 382.

21. *Tableau de l'Angleterre*, I, Brussels, 1788, pp. 149-50, as cited by George, V (1935), pp. xvi-xvii, and 1959, I, p. 13. The translation is mine. George's excellent account of the rise in popularity of English satirical prints both at home and abroad is the basis for my own account of this phenomenon.

22. Ponz, p. 1829. Originally published in 1785, the *Viaje fuera de España* was an extension of Ponz's ambitious, eighteen volume record of his travels within Spain, *Viaje de España* (1772-92).

23. Ponz, p. 1828.

24. This explanation is suggested by Hilton, p. 120.

25. On this subject, see Elorza, and Herr, pp. 181-82.

26. On this subject, and on censorship of the English prints before the Revolution, see Michel Melot's interesting study, "Caricature and the Revolution: The Situation in France in 1789," in *French Caricature*, pp. 25-32.

27. Letter to Joaquín María Ferrer of December 20, 1825; for a transcription and publication history, see Canellas López, pp. 389-90, no. 273. The view that the Inquisition posed no threat to Goya is argued by Harris, 1964, I, p. 106. The opposite position is held by Sayre, 1974, p. 61.

28. The incident was discussed in a series of letters between the publisher Mariano Cabrerizo, who was selling the volumes of the *Caprichos* in Valencia, and an official of the Calcografía Nacional in Madrid. The relevant passages of this correspondence are published in Glendinning, 1989, p. 398.

Goya, the Print Trade, and Anglomania in Spain

1. Estala, p. 20.

2. On the Academy's policy of sending printmakers to France to be trained, but students of the other arts to Italy, see Bédat, pp. 236-64, and Sayre, 1974, p. 1.

3. Descriptions of the print techniques that Sureda had learned during his mid-1790s trip to England can be found in *Spirit of Enlightenment*, pp. 144-48, and Wolf, 1987, pp. 119-26, where their possible relevance for Goya is also considered.

4. On these trends, see Wolf, 1987, pp. 15-61, on which this discussion is based.

5. Boydell, 1779.

6. See Bruntjen, p. 39.

7. Feb. 3, 1787, p. 3. I am grateful to David Alexander for having looked up the original article for me, which was quoted without citation in Whitley, p. 72.

8. *Gaceta de Madrid*, Jan. 25, 1788, p. 64, and receipts for prints purchased by the Osunas, Archivo Histórico Nacional, Madrid, Osuna-Cartas, legs. 418 and 517. On the details of these transactions, see Wolf, 1987, pp. 37-42, and pp. 233-43.

9. See Wolf, 1987, pp. 58-61.

10. These are listed in an inventory published by Ezquerra del Bayo, p. 201.

11. The similarity of this painting to British portraits has often been pointed out. See, for instance, Baticle, 1980, p. 76, and Gállego, pp. 65-66. For a discussion of other portraits in which Goya used this pose, and of its meaning, see Wolf, 1987, pp. 71-82.

12. *Partición Combencional*, fol. 1320v. This was either the mezzotint after Benjamin West's painting by George Sigmund Facius and John Gotlieb Facius, published by Boydell in 1779 (fig. 4), or a French copy of it that was produced two years later by D. P. Pariset (which is probably the version that was announced in the *Correo literario de Europa* on Nov. 8, 1781, p. 366; the *Correo* was one of a handful of periodicals through which Spaniards could learn of the latest trends in the art world at large). Martínez also owned four volumes of English portraits, in colors, a framed print of General Eliot, and a painted portrait of "an English official." *Partición Combencional*, fols. 1249r, 1318v, 1252r, 1306r.

13. "Sr. D. Francisco de Goya," subscription list appended to *Clara Harlowe. Novela traducida del ingles al frances Por Mr. le Tourneur, Siguiendo en todo la edicion original revista por su autor Richardson, y del frances al castellano Por Don Joseph Márcos Gutierrez*, Vol. I, Madrid, 1794, p. vii. I am indebted to Nigel Glendinning for having called my attention to this subscription list and for showing me his copy of it.

14. *Gaceta de Madrid*, Feb. 17, 1795, p. 200. On the interest in Richardson's work in Spain during the 1780s and 1790s, see Coe, pp. 56-63, and Wolf, 1987, pp. 10-13. Thomas O. Beebee, *Clarissa on the Continent: Translation and Seduction*, University Park, Pa., 1990, appeared while this essay was in press. A good survey of the range of English literature that was published in Spain during the eighteenth century is Effross, 1962.

15. Undated letter, *Cartas*, p. 213. The boots were mentioned in a letter to Zapater of March 10, 1787. *Cartas*, p. 161.

16. Letter dated August 1, 1786. *Cartas*, p. 151.

17. A carriage that was built in Spain to rival imported models, the body of which was designed "á la Inglesa," was described in the periodical *Memorial literario*, May 1786, pp. 122, 125. In a satirical dialogue of the following year, revealingly entitled "The Empire of Fashion," a man asks his friend why his horse's ears bleed. The owner replies that the animal is not sick, but rather that his ears have been clipped "á la moda inglesa." Since we all have English carriages, he asks, why not have horses to match? "Paris. El Imperio de la moda," *Espiritu de los mejores diarios*, Oct. 6, 1787, pp. 329-31.

18. See Wolf, 1987, pp. 31-33.

19. *Apuntaciones*, pp. 225-26. Moratín elsewhere harshly criticized the English for their "selfish" monopoly of international trade; *Apuntaciones*, pp. 202-03.

20. "PARIS. Consideraciones sobre el tratado de comercio entre la Francia y la Gran Bretaña, del 26 de Septiembre de 1786: en casa de Prault, 1789," *Espiritu de los mejores diarios*, Nov. 16, 1789, p. 252.

21. Braudel, p. 375.

The *Caprichos* and the Satirical Print in Society: Entertainment and Interpretation

1. Lichtenberg, p. xvii.

2. The passage quoted here is from the title page of *A Political and Satirical History of the Years 1756, 1757, 1758, 1759, and 1760*, 5th ed., London, 1763.

3. See George, 1959, I, p. 176.

4. Hon. George C. Grantley F. Berkeley, *My Life and Recollections*, IV, London, 1867, p. 133, as cited in Patten, pp. 333-34.

5. The bill is dated Jan. 17, 1799. See Gassier and Wilson, p. 384. The purchase was made about three weeks prior to the *Diario de Madrid* advertisement for the *Caprichos*, as has often been pointed out.

6. The garden at the Osuna *Alameda* included all of the standard features of its models: winding paths, an artificial lake and grotto, fanciful garden ornaments (in Spain these were called *caprichos*), such as a colonnaded temple on a hill, a rustic house, and a hermitage furnished with the requisite dummy hermits. On the informal garden and country house of the Duchess of Osuna and for relevant bibliography, see Wolf, 1987, pp. 160-79. Several of the Boydell prints that the duchess had purchased in 1787 were views of famous English houses and gardens. Itemized bill of March 30, 1787, Archivo Histórico Nacional, Madrid, Osuna-Cartas, leg. 418. See Wolf, 1987, p. 162, and pp. 236-38.

7. In an undated letter to Zapater, probably from the late 1780s or early 1790s, Goya wrote, "I am going on horseback to the Alameda; the Duchess of Osuna is there and I must pay her a few visits." *Cartas*, p. 208. On the dating of the letter, see *Cartas*, p. 208.

8. Gassier and Wilson, nos. 663 and 664, painted *c.* 1797-98. The other paintings purchased by the Osunas to decorate the country house are Gassier and Wilson, nos. 659-662, of the same group, and nos. 248-254, of 1786-87. An article about Boydell's Shakespeare Gallery was published in the *Espiritu de los mejores diarios*, Aug. 2, 1787, pp. 101-03, and Moratín had visited the Shakespeare Gallery while in London, according to an entry in his diary of Jan. 26, 1793. *Diario*, p. 95. It is suggested that Goya would have known of projects such as the Shakespeare Gallery through Moratín by Muller, pp. 214-15.

9. Beckford, p. 165.

10. This opinion is maintained in the standard *catalogue raisonné* of Goya's prints. See Harris, 1964, I, p. 98. Harris argued that the Prado commentaries are close in style to the captions that accompany the preparatory drawings and the plates of the *Caprichos*, an opinion that was probably based on López-Rey, 1953, I, p. 84. This view is refuted by Sayre, 1974, p. 57, and *Spirit of Enlightenment*, pp. ci-cii. The Ayala, Biblioteca Nacional, and Prado manuscripts are published in their entirety, with a brief publication history, in Helman, 1963, pp. 219-41.

11. Ten of these manuscripts are described by Sayre in *Spirit of Enlightenment*, pp. ci-ciii. An interesting comparative analysis of several of the variants can be found in Andioc, where it is proposed that the Ayala, Biblioteca Nacional and Prado manuscripts are in themselves probably copies of copies.

12. The dissemination of this volume is discussed in Antal, p. 197, Bruntjen, p. 38, note 58, and Paulson, 1965, I, pp. 77-78.

13. On this point, also see Paulson, 1965, I, p. 77.

14. Rouquet, pp. 19-20.

15. As quoted by Glendinning, 1964, p. 9. The commentary was copied by Francis Douce—a collector of caricatures of all types, who owned a copy of the *Caprichos*—from another that had been made by a merchant named Samuel Dobree. On Douce, Dobree, and for the complete transcription of the commentary, see Glendinning, 1964, pp. 7-9.

16. See *Spirit of Enlightenment*, pp. 164-66, no. 73. Goya's rendering of Juan Antonio Llorente (*c.* 1810-12; Museo de Arte, São Paulo) is among his most sensitive portraits. French copies of some plates of the *Caprichos* were issued in France in 1825; see Harris, 1964, I, pp. 12-13, and II, p. 449. On the interest in Goya's work in France at this time, see Lipschutz.

17. The article appeared anonymously as "Satiras de Goya," *Semanario patriótico* (Cadiz), Mar. 27, 1811. It is published in Harris, "A Contemporary Review." On González Azaola and the essay, also see Glendinning, 1977, pp. 59-61.

18. My translation, from the Spanish published in Harris, "A Contemporary Review," p. 42.

19. Harris, "A Contemporary Review," p. 42. One set of the *Caprichos* even seems to have been modified for the express purpose of discussing the plates in the form of a kind of guessing game. Commentaries were written on the verso of each print of this set. The images themselves had been cut out and mounted on sheets of paper. The captions were also cut out and mounted onto sheets of paper, and were placed in sequence just before the corresponding image. The set is described by Sayre in *Spirit of Enlightenment*, p. cii (Sánchez Gerona commentaries).

20. González Azaola apparently knew both the English and French languages. See Glendinning, 1977, p. 59.

21. Lichtenberg, p. xvii.

22. Harris, "A Contemporary Review," p. 42.

23. Trusler, p. 202.

24. Nichols, pp. 90-91.

25. Lichtenberg, pp. 175-76.

26. Quoted from Helman, 1963, p. 21 of the illustrations.

27. The Ayala, Biblioteca Nacional, Douce, and Lefort manuscripts all identify this man as Godoy. The caption to the print seems to refer to both political and sexual rises and falls. The sexual reference in the caption is discussed in *Spirit of Enlightenment*, pp. 123-24, no. 56. Similar double meanings in other plates of the *Caprichos* are taken up on, for example, p. 39 of this study.

28. In one of several studies about Goya's adaptations of traditional emblems, George Levitine suggests that the satyr-like figure in *To rise and to fall*, which he thinks is Pan, was derived from emblems, out of which Goya then made a kind of modern parody. However, it should be kept in mind that the English prints had in themselves developed partly out of, and also parodied this same emblematic tradition. It is reasonable to think that Goya looked at emblems, English caricatures, and other types of imagery as he worked on the *Caprichos*. The English works are particularly interesting with regard to Goya, however, exactly because they would have contributed to his thinking about parody. In addition, the English prints, unlike the emblems, were up-to-the-minute productions, and for this reason, too, would have had a special appeal for the artist.

29. See George, V (1935), p. 738, no. 6275, and 1959, I, p. 170.

30. See Prevost, p. 146.

31. On Goya's exploration of the fill-in-the-blank aspect of political imagery in his war prints and related drawings, see Wolf, 1990.

32. This is one of a series of copies, to my knowledge unpublished, of the *Caprichos*. A group of these is in the collection of the Biblioteca Nacional, Madrid. In another print that probably belongs to the series, based on plate 43 of the *Caprichos*, the image was also transformed into an anti-Napoleonic political print. See Museo Municipal, II, p. 475, no. 173-11.

33. Several Spanish versions of English anti-Napoleonic caricatures were made. These prints are discussed by Derozier.

34. This set is described in detail by Moralejo Alvarez.

35. Lichtenberg, p. xvi.

Literary Allusions in the English Satirical Print and in the *Caprichos*

1. Helman, 1963, p. 21 of the illustrations.

2. *Apuntaciones*, pp. 183-84.

3. The standard study of Hogarth's associations with Fielding and other writers is Robert E. Moore, *Hogarth's Literary Relationships*, Minneapolis, 1948.

4. *Apuntaciones*, p. 184; also see p. 243, where the analogy is repeated. These passages have been compared to Hogarth's likening of his prints to scenes in the theater and his subjects to actors in his *Autobiographical Notes*; Effross, 1965, p. 50, and Helman, 1963, p. 198, and 1970, p. 126 (trans. rpt. of "*Caprichos* and *Monstruos* of Cadalso and Goya," *Hispanic Review*, 26 (1958)).

5. The passage is quoted in Paulson, 1965, I, p. 189.

6. See Paulson, 1965, I, p. 189.

7. Moratín wrote the first Spanish translation of a play by Shakespeare, *Hamlet*, which was published in 1798.

8. *Amelia*, 1795, p. 67.

9. *Tom Jones*, 1796, pp. 179-80.

10. It is believed that Goya had originally conceived of no. 43, *The dream* [or, *sleep*] *of reason produces monsters*, as the first plate of the *Caprichos*, in which case the association with the Spanish literary tradition of the *sueño* would have been established. See Sayre, *Spirit of Enlightenment*, pp. xcviii-xcix, and pp. 110-15, nos. 50, 51.

11. See Paulson, 1965, I, p. 21.

12. Goya's quotation from the Jovellanos poem has long been known. See Mayer, p. 90, Sánchez Cantón, pp. 27-28, and Helman, 1963, pp. 125-30.

13. See Paulson, 1965, I, pp. 237-38, no. 204.

14. The satyr was probably derived from Hogarth's 1764 metamorphosis of his comic muse's mask into a satyr. On his transformation of the plate, see Paulson, 1965, I, pp. 237-38.

15. Helman, 1963, p. 22 of the illustrations.

16. In Spain, collections of prints were ordinarily offered in installments, often over a period of several years. For example, Juan Battista Bru de Ramón's collection of regional types from Asia was advertised two prints at a time, and these were sold individually: the first plates of the series were advertised in the *Gaceta de Madrid* on Jan. 2, 1784, p. 12, while plates 69 and 70 were advertised in the same newspaper over four years later, on April 15, 1788, p. 248.

17. These volumes are discussed by Paulson, 1965, I, p. 70.

18. These sets were advertised in the list of prints that could be purchased from Mrs. Hogarth that was included in Trusler.

19. On the various editions, and Boydell's purchase of the plates, see Paulson, 1965, I, pp. 70-71.

20. The inscription quoted here appears below Isaac Cruikshank's *The Political Pawn Brokers* of 1793; George, VII (1942), p. 25, no. 8325.

21. The advertisement, appended to *Jordan's Elixir of Life*, is quoted from George, VI (1938), p. xi.

22. It has long been known that the order in which Goya arranged the plates in his book does not follow the order in which they were made. The open-ended, associative fashion in which he sequenced them in the book was part of his creative process. The most thorough study of the chronology of the plates is found in Askew, pp. 425-89. Throughout the first half of this century, it was generally believed that the *Caprichos* was divided into two distinct parts, scenes that concern social interaction, up to plate 43, and supernatural imagery, in the remaining plates. See, for example, Beruete, 1918, p. 36, Mayer, p. 91, and Klingender, 1948, pp. 87-92. More recent scholarship has argued against this interpretation;

Sánchez Cantón, p. 12, López-Rey, 1953, pp. 98-99, and Gassier and Wilson, p. 128.

23. It has been suggested that Goya's print was inspired by Moratín's well-known comedy *El viejo y la niña (The Old Man and the Girl)*, which was first performed in Madrid in 1790. Helman, 1963, p. 128, and 1970, pp. 158-59 (trans. rpt. of "The Younger Moratín and Goya: on *Duendes* and *Brujas*," *Hispanic Review*, 27 (1959)).

24. *Donde menos se piensa salta la liebre*, cited in Cotarelo y Mori, p. 384 and p. 386.

THE *CAPRICHOS* AND STOCK MOTIFS OF THE ENGLISH SATIRICAL PRINT

1. The fast was so described in the *Gazette*, Mar. 1, 1793; cited by George, VII (1942), p. 24, no. 8323.

2. Holland was imprisoned during 1793 for publishing "seditious" books. See Bindman, p. 33, and p. 191, no. 193.

3. See Provost, p. 148.

4. Gassier, 1975, p. 94, no. 57. The depiction of a human head on a plate was a specialty of James Gillray. He had used it in *A Dish of Mutton-Chop's* of 1788, and it turned out to be an especially fitting motif for satires of revolutionary France, in which the favored form of execution was by guillotine. See George, VI (1938), p. 470, no. 7286, and pp. 927-28, no. 8122, and VII (1942), p. 21, no. 8318. The influence of Gillray's work on Goya's drawing, and on plate 13 of the *Caprichos*, have been suggested, respectively, by Hasse, p. 534, and by Paulson, 1983, p. 335.

5. Lichtenberg, p. 295.

6. See George, V (1935), p. 30, no. 4892.

7. The politician was identified as Charles James Fox (1749-1806) in a handwritten inscription on an impression of this print in the collection of the British Museum (no. 4892), and this identification, which would mean that the caption is straightforward rather than ironic, is followed by George, 1959, I, p. 146, and pl. 45. However, the *Last dying Speech* that hangs from the pocket of

the valet who holds up the mirror strongly suggests that the politician is in fact Henry Fox (1705-74).

8. Helman, 1963, p. 227.

9. Helman, 1963, p. 21 of the illustrations.

10. The quote is from Walpole's 1780 advertisement for the final volume of *Anecdotes of Painting in England*. Cited in Riely, 1975, p. 36, and 1983, p. 4. On Walpole's large collection of works by Bunbury, see Riely, 1975.

11. Riely, 1975, p. 32.

12. "Memoirs of the Late Henry William Bunbury, Esq," *The Sporting Magazine*, 41 (1812), as cited in Riely, 1983, p. 5, and p. 7, note 7. For evidence of Reynolds' long-standing friendship with Bunbury, see Riely, 1975, pp. 29-30, and 1983, p. 3 and p. 5.

13. See George, VI (1938), p. 269, no. 6882A. The use of dogs to echo the activities of humans was a standard motif of eighteenth century art that Bunbury adapted with exceptional sensitivity and wit; also see *A Long Story* (no. 12), and *A Chop-House* (no. 22).

14. Translated from the French transcription in George, VI (1938), p. 269, no. 6882A.

15. Illustrated in Antoine de Baecque, *La Caricature revolutionnaire*, with a preface by Michel Vovelle, CNRS, 1988, pp. 32-33.

16. Helman, 1963, p. 229.

17. The two figures are viewed as transvestites by Soubeyroux, p. 129.

18. As in *She plucks him* (no. 32), the women are identified as prostitutes in the Biblioteca Nacional commentary: "A night of strong winds, bad for whores." Helman, 1963, p. 229.

19. For example, see Teresa Lorenzo de Márquez, "Carnival Traditions in Goya's Iconic Language," *Spirit of Enlightenment*, pp. lxxxv-xciv.

20. The two English prints were included in volumes of *Darly's Comic-Prints*, as was *The Female*

Shaver, which apparently had been a model for plate 35 of the *Caprichos*. It seems likely, then, that Goya was familiar with the Darly works.

21. The apparent switched sexual identities, as well as speculation about the identities of the persons pictured, are discussed by George, V (1935), p. 210, nos. 5314 and 5315.

22. This feature of depictions of the *sans culottes* is discussed by Jouve.

23. Paulson, 1965, I, pp. 132-33, no. 108.

24. Stephens, IV (1883), pp. 139-41, no. 3917, and Atherton, p. 250. The animal heads in this print are compared to Goya's ass imagery in plates 37 to 42 of the *Caprichos* by Klingender, 1948, p. 177.

25. The clyster had been used by Daumier's publisher Charles Philipon a few years earlier for the depiction of an apothecary. See Cuno, pp. 347-48. In a discussion of other works by Daumier, Cuno suggests that Philipon had given Daumier as well as other artists the ideas for their subjects, and that the origins of some of these can be found in late eighteenth century English and French prints; p. 350, and p. 354, note 19.

26. The details of this incident are told by Stephens, IV (1883), pp. 410-11, no. 4173.

27. See George, VI (1938), p. 643, no. 7592.

28. A reversed copy of this print is dated 1782. See George, VI (1938), p. 649, no. 7608. Rowlandson's work poses a number of dating problems that remain to be resolved. These are discussed by Baum.

29. It has been suggested that this print was based on story found in several anonymous satirical poems of the time about a quarrel between a monk and a soldier over the latter's lover or wife; Glendinning, 1961, pp. 115-20. However, it should be noted that there is no soldier present in Goya's scene.

30. Gassier and Wilson, no. 663.

31. The relationships between victimizers and victims in the *Caprichos* is emphasized by Soufas; see especially pp. 322-24.

POSE, GESTURE, AND EXPRESSION:
SIGN LANGUAGE IN THE *CAPRICHOS*
AND IN THE SATIRICAL PRINT

1. For other sources for certain gestures and expressions found in the *Caprichos*, see Sayre, 1981.

2. The similarity of Goya's figure to Hogarth's was noted by Busch, p. 237.

3. "Old lascivious men are burned alive, and always have their underpants in their hands"; "An old man who burns all up with lust does not manage to either put on or take off his socks"; and, "It will not occur to him to take off his breeches, or to stop talking to the candle, until the fire squad of the town freshens him up. Such is the power of wine!" Helman, 1963, p. 224.

4. The possibility that Goya borrowed individual faces from Hogarth is proposed by Busch, 1977, p. 235.

5. It seems that a feature of Goya's working process was to excerpt figures from prints, and to rearrange them. The practice is obvious in a group of drawings based on some of John Flaxman's line engraving illustrations to Dante's *Inferno*. These drawings, as well as instances in which Goya seems to have incorporated elements of Flaxman's work into his prints, are discussed extensively by Symmons, 1971, 1979, and 1984.

6. See Gassier, 1975, p. 98, no. 61.

7. Lichtenberg, p. 179. In another English print, *The Flaming Politician Burning with News* of 1789 (The Lewis Walpole Library, Yale University, Farmington, Ct.), a politician setting hair on fire is associated with the French Revolution, as in plate 8 of *Hollandia Regenerata*.

8. Paulson, 1965, I, pp. 179-81, nos. 153, 154. The two tapestry designs have also been compared to French prints. See Tomlinson, pp. 175-78.

9. This possibility is suggested in Tomlinson, p. 178.

10. The tapestry is described by Tomlinson, p. 52. Other sources suppose that a tapestry was never woven from Goya's design for *Winter*. See *Spirit of Enlightenment*, p. 22, no. 10. The scene is interpreted as an illustration of the hardships of the poor in both Tomlinson and *Spirit of Enlightenment*, and Tomlinson implies that this would have been unsettling to Goya's royal patrons, and that it was for this reason that the figures were hidden by the snow when the cartoon was translated into a tapestry.

11. The observation that certain themes of the uncommissioned work had been introduced in the tapestry cartoons is developed by Tomlinson; see especially p. 228.

12. The sexual allusions in the *Ball Game* are fully explored by Tomlinson, pp. 89-93.

13. This interpretation is proposed by Askew, pp. 474-75.

14. This production of multiple significances through a reduction of forms is directly related to the "economy" of means from which the humor of caricature is often derived. For an overview of the literature on this aspect of caricature, see Varnedoe and Gopnik, p. 133.

15. A series of etchings by the Comte de Caylus after the supposed Leonardo drawings was issued in 1730. On the significance of this series for the development of caricature in England, see Lippincott, p. 24 and p. 133. The relationship of these prints to Goya's caricature drawing is discussed by López-Rey, 1953, p. 58. Hogarth had used the particular face that appears in Goya's drawing as an example of caricature in his print *Characters, Caricaturas*. According to Varnedoe and Gopnik, p. 101, and p. 138, "funny faces" and "weird bodies" only appeared in "serious art" in the twentieth century, but their study ignores Goya's psychologically penetrating exploration of the conventions of caricature in plates of the *Caprichos* such as *The Shamefaced*.

16. The relationship of this print to Goya's monks is noted in *Goya y la Constitución*, p. 216. The print is also discussed by Derozier, II, p. 616, no. 191.

17. On the possible derivation of this and other motifs from Gillray, see Hasse, pp. 532-34.

18. On these sets, see Lippincott, pp. 132-34.

19. On Bunbury's association with Patch, see Riely, 1975, pp. 30-31.

20. *Souvenirs et mémoires de madame la Comtesse Merlin, publiés par elle-même*, I, Paris, 1836, pp. 182-85, as quoted in Rodríguez-Moñino, p. 299.

21. Sir William Stirling-Maxwell, *Annals of the Artists of Spain*, III, London, 1848, p. 1266, as quoted in Glendinning, 1977, p. 66.

22. See Boix, p. 65, no. 179.

23. These are discussed by López-Rey, 1953, pp. 57-72. López-Rey proposes that Goya was probably familiar with Johann Kasper Lavater's writings on physiognomy, then widely known in Europe.

24. As quoted in Godfrey, p. 37. Grose's book has a precedent in Mary Darly's *A Book of Caricaturas, on 59 Copper Plates, with ye Principles of Designing, in that Droll & pleasing manner*, of 1762, which also includes several diagrams. Among these is an example of a "concave" face that is even closer to Goya's self-portrait.

CONCLUSION

1. Helman, 1963, p. 235. "*Jeringar*," to vex, also means to syringe.

2. Nichols, pp. 94-95.

3. Trusler, introductory remark on the page facing the dedication.

4. Caricatures in art "were still only good for a laugh" and were not used to bring out the irrational and mysterious in the human psyche until the twentieth century, according to Varnedoe and Gopnik; see especially p. 120, and p. 136. They also claim that Daumier, rather than Goya, added "literal and metaphoric" darkness to the language of caricature, p. 114. The omission of Goya from this history is probably in part due to the fact that it was taken wholesale from E. H. Gombrich, who had also proposed that it was Daumier who first recognized the potential of caricature to penetrate human psychology. See Gombrich, p. 355. Several writers have viewed Goya as a "modern" artist. The most extensive analysis of the "modern" aspects of Goya's work is found in Licht.

ABBREVIATED REFERENCES AND SELECTED BIBLIOGRAPHY

ALEXANDER AND GODFREY
Alexander, David, and Richard T. Godfrey. *Painters and Engraving: The Reproductive Print From Hogarth to Wilkie*. New Haven (Yale Center for British Art), 1980.

ANDIOC
Andioc, René. "Al margen de los *Caprichos*: Las 'explicaciones' manuscritas." *Nueva revista de filología hispánica*, 33 (1984), pp. 257-84.

ANTAL
Antal, Frederick. *Hogarth and His Place in European Art*. London, 1962.

ASKEW
Askew, Mary Huneycutt. *The "Caprichos" of Francisco Goya*. Ph.D. diss., Stanford University, 1988.

ATHERTON
Atherton, Herbert M. *Political Prints in the Age of Hogarth: A Study of the Ideographic Representation of Politics*. Oxford, 1974.

BAREAU
Bareau, Juliet Wilson. *Goya's Prints: The Tomás Harris Collection in the British Museum*. London (British Museum), 1981.

BATICLE, 1971
Baticle, Jeannine. "L'activité de Goya entre 1796 et 1806, vue à travers le 'Diario' de Moratín." *Revue de l'art*, 13 (1971), pp. 111-13.

BATICLE, 1980
———. "La Pintura española en el siglo XVIII." In *El Arte europeo en la Corte de España durante el siglo XVIII*. Madrid (Museo del Prado), 1980, pp. 45-49.

BAUM
Baum, Richard M. "A Rowlandson Chronology." *Art Bulletin*, 20 (1938), pp. 236-50.

BECKFORD
The Journal of William Beckford in Portugal and Spain: 1787-1788. Ed. Alexander Boyd. London, 1954.

BÉDAT
Bédat, Claude. *L'Académie des Beaux-Arts de Madrid 1744-1808: Contribution à l'étude des influences stylistiques et de la mentalité artistique de l'Espagne du XVIIIᵉ siècle*. Toulouse, 1973.

BERUETE, 1918
Beruete y Moret, Aureliano de. *Goya, grabador*. Madrid, 1918.

BERUETE, 1922
———. *Goya as Portrait Painter*. Trans. Selwyn Brinton. Boston and New York, 1922.

BINDMAN
Bindman, David, with contributions by Aileen Dawson and Mark Jones. *The Shadow of the Guillotine: Britain and the French Revolution*. London (British Museum), 1989.

BOIX
Boix, Félix. *Exposición de dibujos originales 1750-1860: Catálogo-Guia*. Madrid, 1922.

BOYDELL, 1779
Boydell, John. *Catalogue raisonné d'un recueil d'estampes d'après les plus beaux tableaux qui soient en Angleterre*. 2 vols. London, 1779, 1783.

BOYDELL, 1787
———, and Josiah Boydell. *A Catalogue of Historical Prints, Various Subjects, Landscapes, Sea Pieces, Views, &c. After the most captial Pictures in England*. Vol. I. London, 1787.

BRAUDEL
Braudel, Fernand. *The Perspective of the World*. Vol. 3 of *Civilization and Capitalism: 15TH-18th Century*. Trans. Siân Reynolds. New York, 1984.

BRUNTJEN
Bruntjen, Hermann Arnold. *John Boydell (1719-1804): A Study of Art Patronage and Publishing in Georgian London*. Ph.D. diss., Stanford University, 1974.

BUSCH
Busch, Werner. *Nachahmung als bürgerliches Kunstprinzip: Ikonographische Zitate bei Hogarth und in seiner Nachfolge*. Hildesheim and New York, 1977.

CANELLAS LÓPEZ
Canellas López, Angel, ed. *Francisco de Goya: Diplomatario*. Zaragoza, 1981.

CARTAS
Agueda, Mercedes, and Xavier de Salas, eds. *Francisco de Goya: Cartas a Martín Zapater*. Madrid, 1982.

COE
Coe, Ada M. "Richardson in Spain." *Hispanic Review*, 3 (1935), pp. 56-63.

COTARELO Y MORI
Cotarelo y Mori, Emilio. *Iriarte y su época*. Madrid, 1897.

CUNO
Cuno, James. "Charles Philipon, La Maison Aubert, and the Business of Caricature in Paris, 1829-41." *Art Journal*, 43 (1983), pp. 347-54.

DEROZIER
Derozier, Claudette. *La Guerre d'Indépendance espagnole à travers l'estampe (1808-1814)*, 4 vols. Lille and Paris, 1976.

EFFROSS, 1962
Effross, Susi Hillburn. *English Influence in Eighteenth-Century Spanish Literature, 1700-1808*. Ph.D. diss., Columbia University, 1962.

EFFROSS, 1965
——. "Leandro Fernández de Moratín in England." *Hispania*, 48 (1965), pp. 43-50.

ELORZA
Elorza, Antonio. *La ideología liberal en la Ilustración española*. Madrid, 1970.

ESPIRITU DE LOS MEJORES DIARIOS
Espiritu de los mejores diarios literarios que se publican en Europa. 1787-91.

ESTALA
Estala, Pedro. *Quatro cartas de un español á un anglómano: En que se manifiesta la perfidia del gobierno de la Inglaterra como perniciosa al género humano, potencias europas y particularmente á la España*. 2nd ed. Cadiz, 1805.

EZQUERRA DEL BAYO
Ezquerra del Bayo, Joaquín. *La duquesa de Alba y Goya: estudio biográfico y artístico*. Madrid, 1928.

FIELDING, *AMELIA*
Fielding, Henry. *Historia de Amelia Booth, escrita en ingles por el famoso Fielding, traducida al castellano por D.R.A.D.Q.* Vol. I. Madrid, 1795.

FIELDING, *TOM JONES*
——. *Tom Jones ó El expósito. Obra escrita en inglés por M. Henrique Fielding. Traducida del Frances por D. Ignacio de Ordejon*. Vol. II. Madrid, 1796.

FRENCH CARICATURE
Cuno, James, et. al. *French Caricature and the French Revolution, 1789-1799*. Los Angeles (Grunwald Center for the Graphic Arts, Wight Art Gallery, University of California), 1988.

GACETA DE MADRID

GÁLLEGO
Gállego, Julián. "Los retratos de Goya." In *Goya en las colecciones madrileñas*. Madrid (Museo del Prado), 1983.

GASSIER, 1973
Gassier, Pierre. *Les dessins de Goya: Les Albums*. Fribourg, 1973.

GASSIER, 1975
——. *Les dessins de Goya*. Vol. II. Fribourg, 1975.

GASSIER AND WILSON
——, and Juliet Wilson. *The Life and Complete Work of Francisco Goya*. Trans. Christine Hauch and Juliet Wilson. New York, 1971.

GEORGE, V (1935), VI (1938), AND VII (1942)
George, Mary Dorothy. *Catalogue of Political and Personal Satires Preserved in the Department of Prints and Drawings in the British Museum*. Vols. V-VII. London, 1935, 1938, 1942.

GEORGE, 1959
——. *English Political Caricature: A Study of Opinion and Propaganda*. 2 vols. Oxford, 1959.

GEORGE, 1967
——. *Hogarth to Cruikshank: Social Change in Graphic Satire*. New York, 1967.

GLENDINNING, 1977
Glendinning, Nigel. *Goya and his Critics*. New Haven and London, 1977.

GLENDINNING, 1964
——. "Goya and England in the Nineteenth Century." *Burlington Magazine*, 116 (1964), pp. 4-14.

GLENDINNING, 1984
——. "Goya's letters to Zapater." *Burlington Magazine*, 126 (1984), pp. 706-07.

GLENDINNING, 1981
——. "Goya's Patrons." *Apollo*, 114 (1981), pp. 236-47.

GLENDINNING, 1961
——. "The Monk and Soldier in Plate 58 of Goya's *Caprichos*." *Journal of the Warburg and Courtauld Institutes*, 24 (1961), pp. 115-20.

GLENDINNING, 1989
——. "Nineteenth-Century Editions of Goya's Etchings: New Details of their Sales Statistics." *Print Quarterly*, 6 (1989), pp. 394-403.

GODFREY
Godfrey, Richard T. *English Caricature 1620 to the Present: Caricaturists and Satirists, their Art, their Purpose and Influence*. London (Victoria and Albert Museum), 1984.

GOMBRICH
Gombrich, E.H. *Art and Illusion: A Study in the Psychology of Pictorial Representation*. 2nd revised ed., 1961. Princeton, 1969.

GOYA Y LA CONSTITUCIÓN
Goya y la Constitución de 1812, Madrid (Museo Municipal), 1982.

GRIFFITHS
Griffiths, Antony. *Prints and Printmaking: An Introduction to the History and Techniques*. New York, 1980.

HALSEY
Halsey, R.T. H. "*'Impolitical Prints': The American Revolution as Pictured by Contemporary English Caricaturists. An Exhibition*." *Bulletin of the New York Public Library*, 43 (1939), pp. 795-829.

HARRIS, "A CONTEMPORARY REVIEW"
Harris, Enriqueta. "A Contemporary Review of Goya's 'Caprichos'." *Burlington Magazine*, 106 (1964), pp. 38-43.

HARRIS, 1964
Harris, Tomás. *Goya: Engravings and Lithographs*. 2 vols. Oxford, 1964.

HASSE
Hasse, Max. "Spott mit dem Spott treiben Bildzitate in der Karikatur des ausgehenden 18. Jahrhunderts." *Zeitschrift für Kunstgeschichte*, 40 (1984), pp. 523-34.

HELMAN, 1970
Helman, Edith. *Jovellanos y Goya*. Madrid, 1970.

HELMAN, 1963
——. *Trasmundo de Goya*. Madrid, 1963.

HERR
Herr, Richard. *The Eighteenth-Century Revolution in Spain*. Princeton, 1958.

HILTON
Hilton, Ronald. "Antonio Ponz en Inglaterra." *Bulletin of Spanish Studies*, 13 (1936), pp. 115-31.

JOUVE
Jouve, Michel. "L'Image du sans-culotte dans la caricature politique anglaise: création d'un stéréotype pictural." *Gazette des Beaux-Arts*, 91 (1978), pp. 187-96.

KLINGENDER, 1948
Klingender, Francis Donald. *Goya in the Democratic Tradition*. London, 1948.

KLINGENDER, 1944
——. *Hogarth and English Caricature*. London and New York, 1944.

LAMBERT
Lambert, Susan. *The Image Multiplied: Five Centuries of Printed Reproductions of Paintings and Drawings*. London, 1987.

LEFORT
Lefort, Paul. *Francisco Goya: Étude biographique et critique suivie de l'essai d'un catalogue raisonné de son oeuvre gravé et lithographié*. Paris, 1877.

LEVITINE
Levitine, George. "Goya's 'Subir y Bajar': Pan and Ambition." *Studies in Romanticism*, 3 (1964), pp. 177-85.

LICHT
Licht, Fred. *Goya: The Origins of the Modern Temper in Art*. New York, 1979.

LICHTENBERG
Herdan, Gustav, and Innes Herdan, eds. and trans. *Lichtenberg's Commentaries on Hogarth's Engravings*. London, 1966.

LIPPINCOTT
Lippincott, Louise. *Selling Art in Georgian London: The Rise of Arthur Pond*. New Haven and London, 1983.

LIPSCHUTZ
Lipschutz, Ilse Hempel. *Spanish Painting and the French Romantics*. Cambridge, MA, 1972.

LÓPEZ-REY, 1953
López-Rey, José. *Goya's Caprichos: Beauty, Reason and Caricature*. 2 vols. Princeton, 1953.

LÓPEZ-REY, 1945
——. "Goya and the World Around Him: A Contribution to the Artist's Life." *Gazette des Beaux-Arts*, 28 (1945), pp. 129-50.

McKENDRICK, BREWER AND PLUMB
McKendrick, Neil, John Brewer, and J. H. Plumb. *The Birth of a Consumer Society: The Commercialization of Eighteenth-Century England*. 1982. Bloomington, 1985.

MALRAUX
Malraux, André. *Saturn: An Essay on Goya*. Trans. C.W. Chilton. London, 1957.

MARTÍNEZ RIPOLL
Martínez Ripoll, Antonio. "Un dibujo inédito de Goya con cabezas caricaturescas." *Goya*, 177 (1983), pp. 110-15.

MAYER
Mayer, August Liebmann. *Francisco de Goya*. Trans. Robert West. London and Toronto, 1924.

MEMORIAL LITERARIO
Memorial literario, instructivo y curioso de la Corte de Madrid.

MORALEJO ALVAREZ
Moralejo Alvarez, María Remedios. "Un ejemplar de la primera edición de los *Caprichos*, de Goya, con comentarios manuscritos, en la Biblioteca de la Facultad de Filosofía y Letras de la Universidad de Zaragoza." *Boletín del Museo e Instituto "Camón Aznar,"* 4 (1981), pp. 5-22.

MORATÍN, *APUNTACIONES*
Fernández de Moratín, Leandro. "Apuntaciones sueltas de Inglaterra." *Obras póstumas de D. Leandro Fernández de Moratín*. Vol. 1. Madrid, 1867, pp. 161-269.

MULLER
Muller, Priscilla E. *Goya's Black Paintings: Truth and Reason in Light and Liberty*. New York, 1984.

MUSEO MUNICIPAL
Carrete, Juan, Estrella de Diego, and Jesusa Vega. *Catálogo del Gabinete de Estampas del Museo Municipal de Madrid: Estampas españolas*. 2 vols. Madrid, 1985.

NICHOLS
Nichols, John. *Biographical Anecdotes of William Hogarth, and a Catalogue of his Works*. London, 1781.

PARDO CANALÍS
Pardo Canalís, Enrique. "Libros y cuadros de Paret en 1787." *Revista de ideas estéticas*, 23 (1965), pp. 107-12.

PARTICIÓN COMBENCIONAL
Partición Combencional de los Bienes quedados por muerte del Sr. Don Sebastián Martínez, Thesorero General del Reino. Drafted by Cayetano Rodríguez Villanueva y Morán. Archivo de Protocolos, Cadiz, leg. II-5387.

PATTEN
Patten, Robert L. "Conventions of Georgian Caricature." *Art Journal*, 43 (1983), pp. 331-38.

PAULSON, 1965
Paulson, Ronald. *Hogarth's Graphic Works*. 2 vols. New Haven and London, 1965.

PAULSON, 1983
——. *Representations of Revolution (1789-1820)*. New Haven and London, 1983.

PEMÁN
Pemán, María. "La colección artística de don Sebastián Martínez, el amigo de Goya, en Cádiz." *Archivo español de arte*, 51 (1978), pp. 53-62.

POLT
Polt, John H. R. "Jovellanos and his English Sources: Economic, Philosophical, and Political Writings." *Transactions of the American Philosophical Society*, 54 (1964).

PONZ
Ponz, Antonio. *Viaje de España seguido de los dos tomos del Viaje fuera de España*. Ed. Casto María del Rivero. Madrid, 1947.

PREVOST
Prevost, Louis. *Honoré Daumier: A Thematic Guide to the Oeuvre*. Ed. and intro., Elizabeth C. Childs. New York and London, 1989.

RIELY, 1983
Riely, John. *Henry William Bunbury: 1750-1811*. Sudbury (Gainsborough's House), 1983.

RIELY, 1975
——. "Horace Walpole and 'the Second Hogarth'." *Eighteenth-Century Studies*, 9 (1975), pp. 28-44.

RODRÍGUEZ-MOÑINO
Rodríguez-Moñino, Antonio. "Incunables goyescos." Ed. Nigel Glendinning. *Bulletin of Hispanic Studies*, 58 (1981), pp. 293-312.

ROUQUET
Rouquet, Jean. *Lettres de Monsieur ** à un de ses amis à Paris, Pour lui expliquer les Estampes de Monsieur Hogarth*. London, 1746.

SALAS
Salas, Xavier de. "Light on the Origin of Los Caprichos." *Burlington Magazine*, 121 (1979), pp. 711-16.

SÁNCHEZ CANTÓN
Sánchez Cantón, Francisco Javier. *Los Caprichos de Goya y sus dibujos preparatorios*. Barcelona, 1949.

SAYRE, 1974
Sayre, Eleanor A., with the Department of Prints and Drawings, Museum of Fine Arts, Boston. *The Changing Image: Prints by Francisco Goya*. Boston (Museum of Fine Arts), 1974.

SAYRE, 1981
——. "Goyas Gebärdensprache." In Stuffmann, Margaret. *Goya: Zeichnungen und Druckgraphik*. Frankfurt (Städtische Galerie im Städelschen Kunstinstitut), 1981, pp. 82-87.

SOUBEYROUX
Soubeyroux, Jacques. "Ordre social et subversion d'ordre dans les caprices de Goya (Essai d'approche sémiologique)," *Imprévue*, 2 (1981), pp. 107-37.

SOUFAS
Soufas, C. Christopher. " 'Esto si que es leer': learning to read Goya's *Los Caprichos*." *Word & Image*, 2 (1986), pp. 311-30.

SPIRIT OF ENLIGHTENMENT
Pérez Sánchez, Alfonso E., and Eleanor A. Sayre, Codirectors. *Goya and the Spirit of Enlightenment*. Boston (Museum of Fine Arts), 1989.

STEPHENS, III (1877), IV (1883)
Stephens, Frederic George. *Catalogue of Political and Personal Satires Preserved in the Department of Prints and Drawings in the British Museum*. Vols. III, IV. London, 1877, 1883.

SYMMONS, 1983
Symmons, Sarah. "Flaxman and the Continent." In *John Flaxman*. Ed. David Bindman. London, 1979, pp. 152-64.

SYMMONS, 1979
——. *Flaxman and Europe: The Outline Illustrations and their Influence*. New York and London, 1984.

SYMMONS, 1971
——. "John Flaxman and Francisco Goya: Infernos Transcribed." *Burlington Magazine*, 113 (1971), pp. 508-12.

TOMLINSON
Tomlinson, Janis A. *Francisco Goya: The Tapestry Cartoons and Early Career at the Court of Madrid*. Cambridge, 1989.

TRUSLER
Trusler, John. *Hogarth Moralized, Being a Complete Edition of Hogarth's Works*. London, 1768.

VARNEDOE AND GOPNIK
Varnedoe, Kirk, and Adam Gopnik. *High and Low: Modern Art and Popular Culture*. New York (The Museum of Modern Art), 1990.

WHITLEY
Whitley, William T. *Artists and their Friends in England 1700-1799*. 2 vols. London and Boston, 1928.

WOLF, 1987
Wolf, Reva. *Goya and the Interest in British Art and Aesthetics in Late Eighteenth-Century Spain*. Ph.D. diss., New York University, 1987.

WOLF, 1990
——. "Onlooker, Witness, and Judge in Goya's *Disasters of War*." In *Fatal Consequences: Callot, Goya, and the Horrors of War*. Hanover, N. H. (Hood Museum of Art, Dartmouth College), 1990, pp. 37-52.

LIST OF WORKS IN THE EXHIBITION

(Measurements are of platemarks, unless otherwise indicated)

1
William Hogarth
A Midnight Modern Conversation
1732-33
Etching and engraving
34.5 x 47 cm.
Print Collection, The Lewis Walpole Library,
Yale University

2
Elisha Kirkall, after William Hogarth
A Modern Midnight Conversation
c. 1733
Mezzotint
33.7 x 44.8 cm.
Yale Center for British Art, Paul Mellon Fund

3a
Ernst Riepenhausen, after William Hogarth
*A Midnight Modern Conversation / Le[s] buveurs
de Ponche (The Punch Drinkers)*
Plate 2 of a bound volume of 7 engravings made
to accompany Georg Christoph Lichtenberg,
*Ausfürliche Erklärung der hogarthischen
Kupferstiche*, I, Göttingen
1794
Engraving
23.5 x 34.5 cm.
Yale Collection of German Literature

3b
Georg Christoph Lichtenberg
Ausfürliche Erklärung der hogarthischen

Kupferstiche, I, Göttingen, page 81
(first page of text on *A Midnight Modern
Conversation*)
1794
Letterpress
14.5 x 8.5 cm. (page)
Yale Collection of German Literature

4
Vincenz Raimund Grüner, after
Ernst Riepenhausen, after
William Hogarth
*A Midnight Modern Conversation / Les buveurs
de Ponche (The Punch Drinkers)*
Fold-out plate tipped in at the end of
*G. C. Lichtenberg's Witzige und Launige
Sittengemählde nach Hogarth. Für Gebildete
Leser Bearbeitet und Herausgegeben von
Johann Schwinghamer*, I, Vienna
1811
Etching
19.9 x 28 cm.
Yale Collection of German Literature

5
Valentin Carderera
Manuscript Explanation of the *Caprichos*,
Explicacion de lo que representan . . .
Pen and brown ink
30.2 x 21.4 cm. (sheet)
Museum of Fine Arts, Boston
Gift of Eleanor A. Sayre

6
Juan Antonio Llorente
Manuscript Explanation of the *Caprichos*,
Caprices de Goya
Pen and brown ink
23.5 x 36 cm. (sheet)
Museum of Fine Arts, Boston
Gift of Eleanor A. Sayre

7
Francisco Goya
Subir y bajar (To rise and to fall)
The *Caprichos*, plate 56
c. 1797-98
Etching and aquatint
21.5 x 15.1 cm.
Worcester Art Museum, Worcester,
Massachusetts

8
Anonymous [Samuel Collings?]
*The Political Balloon; or, the fall of East
India Stock*
1783
Etching
32.2 x 23.1 cm. (sheet cut within platemark)
Print Collection, The Lewis Walpole Library,
Yale University

9
Thomas Rowlandson
*Brittannia Roused, or the Coalition Monsters
Destroyed*

1784
Hand-colored etching
27 x 20.2 cm.
Beinecke Rare Book and Manuscript Library,
Yale University

10

James Gillray
*Fighting for the Dunghill: or Jack Tar
Settling Buonaparte*
1798
Hand-colored aquatint with etching
24 x 34.7 cm. (sheet cut within platemark)
Print Collection, The Lewis Walpole Library,
Yale University

11

Honoré Daumier
Les nouveaux Icares (The new Icaruses)
Actualités, no. 140
1850 (published in *le Charivari*, June 7, 1850)
Lithograph
27.4 x 21.6 cm.
Boston Public Library, Print Department

12

Henry William Bunbury
A Long Story
1802 (reissue of a print published in 1782)
Stipple engraving with etching
29.1 x 38 cm. (sheet cut within platemark)
Print Collection, The Lewis Walpole Library,
Yale University

13

Francisco Goya
*Fran.co Goya y Lucientes Pintor (Francisco Goya
y Lucientes Painter)*
The *Caprichos*, plate 1
c. 1797-98
Etching and aquatint
21.5 x 15.1 cm.
Worcester Art Museum, Worcester,
Massachusetts

14

William Hogarth
Gulielmus Hogarth
1749
Etching and engraving
53.8 x 26.1 cm. (image)
Yale Center for British Art, Paul Mellon
Collection

15

Thomas Patch
Tommaso Patch Autore (Thomas Patch Author)
From *Caricatures*
1768
Etching
33.2 x 24.5 cm.
Yale Center for British Art, Paul Mellon
Collection

16

John Boydell, publisher
Title page, *The Original and Genuine Works
of William Hogarth*, London
1790
Letterpress
65.3 x 47.8 cm. (page is creased)
Boston Public Library, Print Department

17

John Boydell, publisher
Contents page, *The Original and Genuine Works
of William Hogarth*, London
1790
Letterpress
65.4 x 48.2 cm. (page folded along left edge)
Boston Public Library, Print Department

18

Francisco Goya
Estan calientes (They are hot)
The *Caprichos*, plate 13
c. 1797-98
Etching and aquatint
21.5 x 15 cm.
Museum of Fine Arts, Boston
Gift of Katherine Bullard, 1914

19

Thomas Rowlandson
The Parsonage
n.d.
Black chalk, pen and brown ink, and watercolor
22.9 x 31.5 cm.
Boston Public Library, Print Department

20

Richard Newton
Fast Day!
1793
Hand-colored aquatint with etching
24.8 x 35.3 cm.
Print Collection, The Lewis Walpole Library,
Yale University

21

Honoré Daumier
*Capucinade: La Pauvreté Contente
('Capucinade': Poverty Content)*
Actualités, no. 88
1851 (published in *le Charivari*,
March 14, 1851)
Lithograph
19.2 x 27.3 cm.
Boston Public Library, Print Department

22

Henry William Bunbury
Etched by William Dickinson
A Chop-House
1781
Stipple engraving
29.3 x 34.8 cm. (design)
The Pierpont Morgan Library,
Peel Collection, Vol. V, No. 281

23

Francisco Goya
Esto si que es leer (This is certainly being able to read)
The *Caprichos*, plate 29
c. 1797-98
Etching and aquatint
21.5 x 14.7 cm.
Worcester Art Museum, Worcester,
Massachusetts

24
William Hogarth
Night
The Four Times of Day, plate 4
1738
Etching and engraving
44.5 x 36.8 cm. (sheet cut within platemark)
Print Collection, The Lewis Walpole Library,
Yale University

25
Anonymous, after Samuel Hieronymous Grimm
The Politician
1771
Engraving
36.2 x 26 cm.
Yale Center for British Art,
Paul Mellon Collection

26
Anonymous
The Young Politician
c. 1771
Hand-colored etching and engraving
25.3 x 20.5 cm.
Print Collection, The Lewis Walpole Library,
Yale University

27
Thomas Rowlandson
A Sufferer for Decency
1789
Hand-colored etching and aquatint
34 x 21 cm.
Beinecke Rare Book and Manuscript Library,
Yale University

28
Thomas Rowlandson
A Penny Barber (pendant to no. 27)
1789
Hand-colored etching and aquatint
34.4 x 24.5 cm.
Beinecke Rare Book and Manuscript Library,
Yale University

29
Honoré Daumier
Quand le journal est trop interressant
(When the newspaper is too interesting)
Les Bons Bourgeois, no. 12
1846 (published in *le Charivari*, August 12, 1846)
Hand-colored lithograph
24.5 x 20.8 cm.
Boston Public Library, Print Department

30
Honoré Daumier
Comment! le journal annonce que le bruit a couru
à la bourse que les Russes ont franchi le Pruth!
(What! The newspaper reports that Russia has
passed through 'le Pruth!')
Actualités, no. 24
1853 (published in *le Charivari*, June 24, 1853)
Lithograph
19 x 25.8 cm.
Boston Public Library, Print Department

31
Anonymous
The Patriotick Barber of New York, or the
Captain in the Suds
1775
Hand-colored mezzotint and engraving
35.4 x 25.2 cm.
Boston Public Library, Print Department

32
Francisco Goya
Le descañona (She plucks him)
The *Caprichos*, plate 35
c. 1797-98
Etching and aquatint
21.5 x 15 cm.
Museum of Fine Arts, Boston
Gift of Katherine Bullard, 1914

33
Anonymous [Mary or Matthew Darly?]
The Female Shaver
1773
Etching and engraving
24.8 x 17.5 cm.

Print Collection, The Lewis Walpole Library,
Yale University

34
Anonymous
Cap.tn Puff, in the Suds, or the Fashionable
Advertiser—Looseing his Wiskers
1787
Etching
26.5 x 21.9 cm.
Prints and Photographs Division,
Library of Congress

35
Francisco Goya
Mala noche (A bad night)
The *Caprichos*, plate 36
c. 1797-98
Etching and aquatint
21.5 x 15 cm.
Museum of Fine Arts, Boston
Gift of Katherine Bullard, 1914

36
Anonymous
Ad E. Rout or Reynard in his Element
1784
Hand-colored etching
22.3 x 33.3 cm. (sheet cut within platemark)
Print Collection, The Lewis Walpole Library,
Yale University

37
Charles Mosley
A Prospect in a High Wind
1751
Etching and engraving
38 x 26.3 cm.
Print Collection, The Lewis Walpole Library,
Yale University

38
Francisco Goya
Ya tienen asiento (Now they have a seat)
The *Caprichos*, plate 26
c. 1797-98
Etching and aquatint

21.5 x 15 cm.
Museum of Fine Arts, Boston
Gift of Katherine Bullard, 1914

39
Francisco Goya
El Vergonzoso (The Shamefaced)
The *Caprichos*, plate 54
c. 1797-98
Etching and aquatint
21.5 x 15.1 cm.
Worcester Art Museum, Worcester,
Massachusetts

40
Thomas Rowlandson
Inn Yard on Fire
1791
Hand-colored etching and aquatint
33.5 x 46 cm.
Beinecke Rare Book and Manuscript Library,
Yale University

41
Francisco Goya
Tragala perro (Swallow it, dog)
The *Caprichos*, plate 58
c. 1797-98
Etching and aquatint
21.4 x 15.2 cm.
Worcester Art Museum, Worcester,
Massachusetts

42
Anonymous
*The Evacuations. or an Emetic for Old England
Glorys-Tune Derry Down*
1762
Etching and engraving
30.1 x 20 cm.
Print Collection, The Lewis Walpole Library,
Yale University

43
Honoré Daumier
*Le Reméde de Mimi Véron (The Remedy of
Mimi Véron)*

Actualités, no. 124
1850 (published in *le Charivari*, May 14, 1850)
Lithograph
20.9 x 27.1 cm.
Boston Public Library, Print Department

44
Honoré Daumier
*Monseigneur s'ils persistent nous mettrons Paris en
état de siège (Monseigneur, if they persist we
will put Paris in a state of siege)*
1831
Hand-colored lithograph
25 x 22 cm.
Boston Public Library, Print Department

45
Anonymous
*The Siege of Warwick-Castle; or The Battle
between the Fellows & Licentiates*
1768
Etching and engraving
9.9 x 15.6 cm. (sheet cut within platemark)
Print Collection, The Lewis Walpole Library,
Yale University

46
Thomas Rowlandson
The Doctor Dismissing Death
1785
Etching and aquatint
34 x 38.9 cm.
Department of Prints and Photographs,
The Metropolitan Museum of Art,
The Elisha Whittelsey
Collection, The Elisha Whittelsey Fund, 1959

47
Francisco Goya
Ysele quema la Casa (And he sets the house on fire)
The *Caprichos*, plate 18
c. 1797-98
Etching and aquatint
21.3 x 15.1 cm.
Worcester Art Museum, Worcester,
Massachusetts

48
William Hogarth
After
1736
Etching and engraving
37.4 x 31 cm. (sheet cut within platemark)
Print Collection, The Lewis Walpole Library,
Yale University

49
William Hogarth
A Rake's Progress, plate 3
1735
Etching and engraving
35.5 x 40.8 cm.
Print Collection, The Lewis Walpole Library,
Yale University

50
David Hess
Etched by James Gillray (?)
*Il comitato di pubblica vigilanza (The Committee
of Public Vigilance)*
*La Rigenerazione dell'Olanda speechio a tutti i popoli
rigenerati*, Venice, 1799, plate 8 and text on
facing page
Etching and letterpress
37.3 x 51.1 cm. (plate and text)
Yale Center for British Art, Paul Mellon Fund
(Exhibited: Dutch edition of 1796, plate only,
Print Collection, The Lewis Walpole Library,
Yale University)

51
Henry William Bunbury
Night
1794
Pencil and watercolor
12.3 x 8.1 cm. (sheet cut within design)
The Lewis Walpole Library, Yale University

52
George Murgatroyd Woodward
Etched by Thomas Rowlandson
Late Hours!
Matrimonial Comforts, "Sketch" 2

1799
Hand-colored etching
25.3 x 21 cm.
Beinecke Rare Book and Manuscript Library,
Yale University

53
Honoré Daumier
La rentrée entre onze heures et minuit (The return home between eleven o'clock and midnight)
Les Bons Bourgeois, no. 76
1847 (published in *le Charivari*,
November 16, 1847)
Hand-colored lithograph
25 x 20.6 cm.
Boston Public Library, Print Department

54
George Murgatroyd Woodward
A Choice Spirit
Gradation from a Greenhorn to a Blood . . .,
London, 1790, plate 6 and text on facing page
Etching and aquatint, and letterpress
39.4 x 48.2 cm. (plate and text)

Yale Center for British Art, Paul Mellon Fund

55
George Murgatroyd Woodward
May the Pleasures of the Evening bear the Morning's Reflection
Elements of Bacchus; . . ., 1792, plate and facing page (77)
Aquatint with etching, and letterpress
24.1 x 16.6 (plate only)
Print Collection, The Lewis Walpole Library,
Yale University

56
Thomas Rowlandson (attributed to)
Introduction
1793
Hand-colored etching
25.9 x 35.5 cm.
Beinecke Rare Book and Manuscript Library,
Yale University

57
Francisco Goya

Que sacrificio! (What a sacrifice!)
The *Caprichos*, plate 14
c. 1797-98
Etching and aquatint
19.6 x 14.9 cm.
Worcester Art Museum, Worcester,
Massachusetts

58
Thomas Rowlandson
Liberality & Desire
1788
Hand-colored etching
36.3 x 26.8 cm.
Beinecke Rare Book and Manuscript Library,
Yale University

59
The *Caprichos*, binding
Brown calf
31.8 x 21.5 cm.
Worcester Art Museum, Worcester,
Massachusetts
(unpictured)

LIST OF FIGURES

Ya van desplumados (They already go, plucked)
The *Caprichos*, plate 20
c. 1797-98
Aquatint and etching
Boston Public Library, Print Department

6
Anonymous
*El castigo de la golosina / Ya van desplumados
(The punishment of desire / They already go,
plucked)*
c. 1812-13
Etching
Biblioteca Nacional, Madrid

7
Anonymous
*Sorpresa que causò á los parientes y amigos de Josef
Botellas, estando en sus diversiones favoritas, la
noticia de su salida precipitada de Madrid (The
Surprise with which the relatives and friends of
Joseph "Botellas," involved in their favorite enter-
tainments, received the news of his sudden depar-
ture from Madrid)*
c. 1813
Hand-colored engraving
Museo Municipal, Madrid

8
Anonymous [Mary or Matthew Darly?]
The Last Drop
1773
Etching
Biblioteca Nacional, Madrid

9
Francisco Goya
*El si pronuncian y la mano alargan Al primero
que llega (They say yes and give their hand to
the first who takes it)*
The *Caprichos*, plate 2
c. 1797-98
Etching and aquatint
Boston Public Library, Print Department

10
[Francisco Goya]

The *Caprichos*, front cover of binding
c. 1830-40
Boston Public Library, Print Department

11
Francisco Goya
Caricatura alegre (Happy caricature)
Album B (Madrid Album), page 63
c. 1796-97
Indian ink wash
Museo del Prado, Madrid

12
George Murgatroyd Woodward
Etched by Thomas Rowlandson
Barber
Country Characters, no. 3
1799
Etching
The British Museum, Department of Prints
and Drawings

13
Francisco Goya
Untitled (barber)
c. 1797
Sanguine wash and red chalk drawing
Museo del Prado, Madrid

14
Francisco Goya
*Gran mano para hurtar sonajas (Por q: era tremulo)
(A fine hand for robbing tambourines
(Because he was trembling))*
Album C, page 80
c. 1810-20
Sepia wash
Museo del Prado, Madrid

15
Anonymous
Intelligence on the Change in Ministry
1782
Hand-colored mezzotint
The Harry Elkins Widener Collection,
Harvard University Library

16
"Argus"
The Continental Shaveing Shop
1806
Hand-colored etching
The Houghton Library, Harvard University

17
Anonymous
General Frost Shaveing Little Boney
1812
Hand-colored etching
The Houghton Library, Harvard University

18
Anonymous
The Allies Shaving Shop or Boney in the Suds
1813
Hand-colored etching
The Houghton Library, Harvard University

19
Henry William Bunbury
Etched by John Jones
A Barbers Shop
1785
Stipple engraving and etching
Print Collection, The Lewis Walpole Library,
Yale University

20
Christian Gottfried Heinrich Geissler
*Die Leipziger Barbierstube (The Leipzig
Barbershop)*
c. 1813
Hand-colored etching and aquatint
The Houghton Library, Harvard University

21
Anonymous
*Des grossen Mannes kleine Hofhaltung auf der
glückseligen Insel (The great man's little
royal household on the blissful island)*
c. 1814
Hand-colored etching
The Houghton Library, Harvard University

22
Francisco Goya
Jesus que Aire (Jesus what a Wind)
Album B (Madrid Album), page 81
c. 1796-97
Indian ink wash
Private Collection, Paris

23
Anonymous [Mary or Matthew Darly?]
The Petticoat at the Fieri Maschareta
1775
Hand-colored etching
The Harry Elkins Widener Collection,
Harvard University Library

24
Anonymous [Mary or Matthew Darly?]
The Breeches in the Fiera Maschereta
1775
Hand-colored etching
The Harry Elkins Widener Collection,
Harvard University Library

25
Anonymous [Thomas Rowlandson?]
Mercury and his Advocates Defeated,
or Vegetable Intrenchment
1789
Hand-colored etching
The British Museum, Department of Prints
and Drawings

26
Francisco Goya
Bien tirada está (It is well stretched)
The *Caprichos*, plate 17
c. 1797-98
Etching and aquatint
Boston Public Library, Print Department

27
David Hess
Etched by James Gillray (?)
Het Committe van Algemeen Waakzaamheid
(The Committee of Public Vigilance)

Hollandia Regenerata, plate 8 and text
on facing page
1797
Etching and letterpress
Department of Printing and Graphic Arts,
The Houghton Library, Harvard University

28
George Murgatroyd Woodward
Quite finished?
Symptoms of Drunkenness, "Sketch" 6
1790
Etching and aquatint
The British Museum, Department of Prints
and Drawings

29
Francisco Goya
The Drunken Mason
1786-87
Oil on canvas
Museo del Prado, Madrid

30
Francisco Goya
Winter
1786-87
Oil on canvas
Museo del Prado, Madrid

31
Francisco Goya
Porque esconderlos? (Why hide them?)
The *Caprichos*, plate 30
c. 1797-98
Etching and aquatint
Boston Public Library, Print Department

32
Thomas Rowlandson
The Introduction
1798 (?)
Fitzwilliam Museum, Cambridge

33
Anonymous [Thomas Rowlandson]
Ladies Trading on their Own Bottom

n.d.
Hand-colored etching
Biblioteca Nacional, Madrid

34
Francisco Goya
Ruega por ella (Pray for her / She prays for her)
The *Caprichos*, plate 31
c. 1797-98
Etching and aquatint
Boston Public Library, Print Department

35
Francisco Goya
Caricat⁹ / Le pide cuentas la muger al marido
(Caricatures / The wife asks her husband
for an explanation)
Album B (Madrid Album), page 58
c. 1796-97
Indian ink wash
Private Collection, Paris

36
Francisco Goya
Caricatura dlas carracas (Caricature of the
carracans)
Album B (Madrid Album), page 62
c. 1796-97
Indian ink wash
Musée du Louvre, Paris

37
Francisco Goya
Caricat⁹ es dia de su Santo (Caricatures it is
her [his?] Saint's day)
Album B (Madrid Album), page 61
c. 1796-97
Indian ink wash
Musée du Louvre, Paris

38
Francisco Goya
Caricature heads
c. 1798
Red chalk drawing
Private Collection, Barcelona

39
George Murgatroyd Woodward
Etched by Thomas Rowlandson
Behaviour at Table
Chesterfield Travestie; or, School for Modern Manners, fold-out plate in bound volume
1808

Hand-colored etching
The Houghton Library, Harvard University

40
Francis Grose
Rules for Drawing Caricatures . . . , London, 1789, plate I

1788
Etching
Department of Prints and Photographs, The Metropolitan Museum of Art, The Elisha Whittelsey Collection, The Elisha Whittelsey Fund, 1963

Index of Works,
by Artist and Printmaker